This vegetable Earth is but a shadow

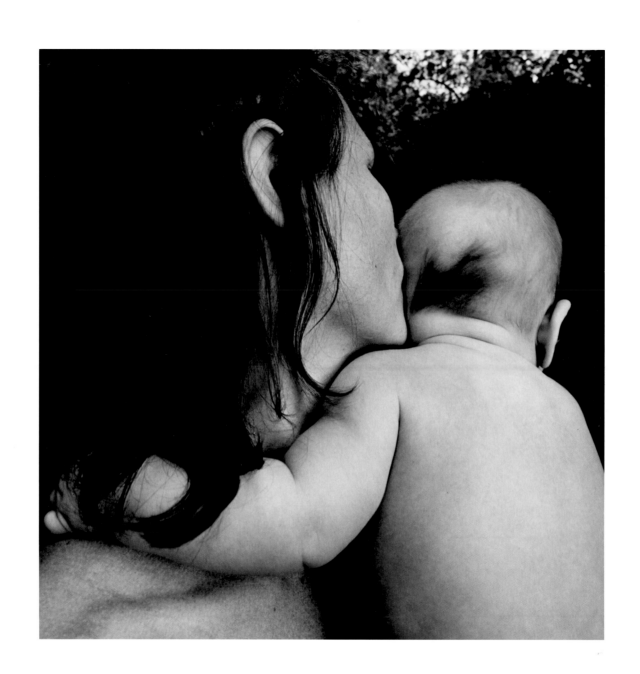

Emmet Gowin

Photographs

Philadelphia Museum of Art

Bulfinch Press • Little, Brown and Company

Boston • Toronto • London

For Edith, Elijah, and Isaac

PUBLISHED on the occasion of an exhibition shown at the Philadelphia Museum of Art, December 8, 1990–February 24, 1991; The Detroit Institute of Arts, May 17–July 14, 1991; The Minneapolis Institute of Arts, August 17–October 13, 1991; Virginia Museum of Fine Arts, Richmond, February 14–April 12, 1992; The Friends of Photography, San Francisco, May 13–July 12, 1992; Museum of Contemporary Art, Chicago, November 20, 1992–January 17, 1993; Columbus Museum of Art, March 14–April 25, 1993.

FRONTISPIECE: *Edith and Isaac, Newtown, Pennsylvania, 1974*

FIRST UNITED STATES TRADE EDITION

BULFINCH PRESS is an imprint and trademark of Little, Brown and Company (Inc.). Published simultaneously in Canada by Little, Brown & Company (Canada) Limited

PRINTED IN THE UNITED STATES OF AMERICA

THE EXHIBITION AND CATALOGUE are supported by grants from The Pew Charitable Trusts, the National Endowment for the Arts, the Charina Foundation, Inc., the Polaroid Foundation, and Judith and Frank Norris.

Additional support for the catalogue has been provided by Agfa Corporation.

QUOTATION from D.H. Lawrence, p. 9: From *The Complete Poems of D.H. Lawrence*, collected and edited by Vivian de Sola Pinto and F. Warren Roberts. Copyright © 1964, 1971 by Angelo Ravagli and C.M. Weekley, Executors of the Estate of Frieda Lawrence Ravagli. Reprinted by permission of the publisher, Viking Penguin, a division of Penguin Books USA Inc.

Quotations from William Carlos Williams, pp. 28 and 76: William Carlos Williams, *The Collected Poems of William Carlos Williams, 1939–1962, vol. II.* Copyright © 1962 by William Carlos Williams. Reprinted by permission of New Directions Publishing Corporation.

Quotation from Richard Rhodes, p. 110: Richard Rhodes, *The Making of the Atomic Bomb.* Copyright © 1986 by Richard Rhodes. Reprinted by permission of Simon & Schuster, Inc.

LIBRARY OF CONGRESS CATALOGING-IN-PUBLICATION DATA
Gowin, Emmet, 1941–
 Emmet Gowin—photographs.
 p. cm.
 ISBN 0–8212–1835–2 (Bulfinch : cloth) : $60.00.—ISBN
0–87633–085–5 (Museum : paper) : $25.00
 1. Photography, Artistic—Exhibitions. 2. Gowin, Emmet, 1941—
Exhibitions. I. Philadelphia Museum of Art. II. Title.
TR647.G69 1990
779'.092—dc20
 90–46910
 CIP

Foreword

The Alfred Stieglitz Center of the Philadelphia Museum of Art was created in 1967 to focus the Museum's energies in the field of collecting and exhibiting photographs. The present exhibition, devoted to the work of Emmet Gowin, is one of the Center's ongoing sequence of monographic presentations of the photographs of remarkable and intensely individual artists, such as Frederick H. Evans, Paul Strand, Josef Sudek, and Robert Frank.

It would not have been possible to assemble such a choice and concentrated selection of Gowin's photographs created over the past twenty-five years without the help of Emmet Gowin, who has made available so many of his fine prints, and of the Pace/MacGill Gallery of New York, the artist's representative, which has been of much assistance with loans and in many other ways. We owe a debt of thanks to the enthusiasm of lenders who have parted with favorite prints: David Breskin; Collection F. C. Gundlach, Hamburg; Mr. and Mrs. Mark M. Iger; John J. Medveckis; Richard and Ronay Menschel; The Miller-Plummer Collection of Photography; Paul, Wiess, Rifkind, Wharton & Garrison; and Marian L. Schwarz. The exhibition and catalogue are generously supported by a partnership in which The Pew Charitable Trusts, the National Endowment for the Arts, the Charina Foundation, Inc., the Polaroid Foundation, Agfa Corporation, and Judith and Frank Norris each played a vital role, and for which we are deeply grateful.

Martha Chahroudi, Associate Curator of Photographs at the Museum, first proposed this project in 1987; she has organized the exhibition and written the introduction to this book with admirable clarity and eloquence. We join her in expressing warm thanks to Peter C. Bunnell, Harry Callahan, Thomas Carabasi, Edith Gowin, Peter MacGill, and Frederick Sommer for their advice and assistance. Sherry Babbitt, Editor in the Department of Publications at the Philadelphia Museum of Art, gave the manuscript her customary careful attention. The production of this handsome catalogue, so sensitively designed by Eleanor Caponigro, was overseen by George H. Marcus, Head of Publications at the Museum. Richard Benson provided essential technical advice, and Franklin Graphics admirably handled the complicated printing. We owe a particular debt to Robert J. Hennessey, whose masterful creation of the printing negatives has produced such fine reproductions of Gowin's original photographs.

Above all, we are grateful to Emmet Gowin, who has given this project such thoughtful and creative attention from its inception and has been infinitely patient with myriad details. It is our hope that audiences in Philadelphia and cities across the United States, where the exhibition will travel, will share our sense of the power of Gowin's vision and his own deep conviction that "the challenge of photography is to show the thing photographed so that our feelings are awakened and hidden aspects are revealed to us."

Anne d'Harnoncourt
The George D. Widener Director

Innis Howe Shoemaker
Senior Curator
Prints, Drawings, and Photographs

5

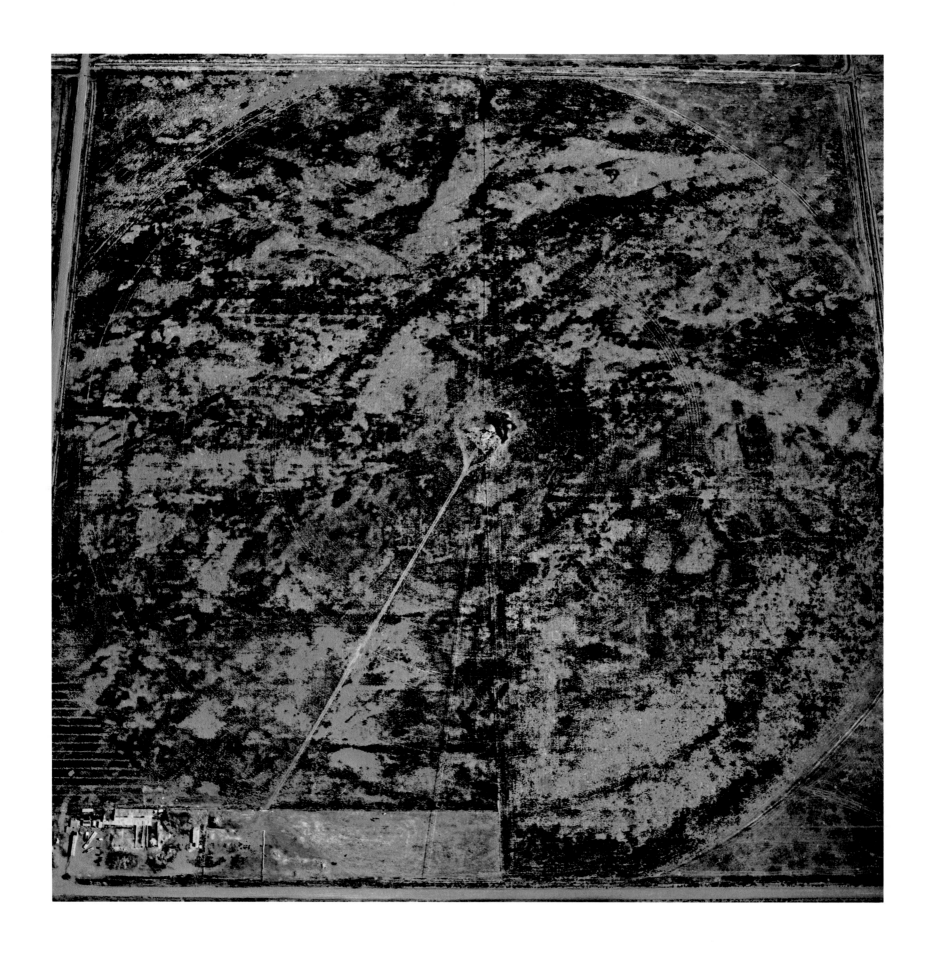

Pivot Agriculture, Dry Sea Bed Near Monte Vista, Colorado, 1989

Introduction

EMMET GOWIN was born on December 22, 1941, in Danville, Virginia. A year later and a mile apart, as he is fond of saying, his wife Edith was born. His father, Emmet Gowin, Sr., was the minister of the Fairview Methodist Church, which Edith's family attended, and his mother, born Lynden Grace Parker, played the church organ. Emmet and Edith did not meet until 1961, the year that he entered the Richmond Professional Institute and began to study photography. These few details of biography hint at a life blessed by stability and good fortune. From all outward appearances, Gowin's life has followed a straight path, and, in the spirit of his religious upbringing, he attributes this to Providence, not will. His longtime friend and mentor, the photographer Frederick Sommer, says of Gowin that he is an atypically American phenomenon: nonaggressive, connected to his past, wholly believing in his ideals, and consistent in his feelings. He is, more than most people, creatively engaged with his heart, mind, and soul in his family, his work, and now his world. This intense engagement is his strength, expressed in the mildest of manners, but with a hard core of certainty and protectiveness of its value.

When asked about his family, Gowin speaks first of his mother, who was the daughter of a western Quaker minister. Because a Quaker minister was not paid, the Parkers moved from Oklahoma to California to Kansas, making a living from carpentry and farming. The family was close-knit, and it was their devotion to each other and to their religion that made a lasting impression on Gowin:

I had never heard of such devotion in other families. When my mother went to Friends Bible College in Haviland, Kansas, the family sold their farm and went with her. When she enrolled at Asbury College in Kentucky, they moved again to be nearby. As a piano major, she practiced six hours a day. My grandmother would read my mother's college textbooks aloud to save her sight for reading music.[1]

Gowin's father, he speculates, was named after Robert Emmet, the Irish nationalist martyr. Born on a farm in Buckingham County, Virginia, the third of ten children, he was the intellectual of the family. His father, Elijah, an authoritative and demanding man, wanted him to become a doctor, but his mind was set on becoming a minister. So, at a time when it was not necessary to have a degree to be a minister, he worked his way through high school, college, and seminary with no assistance from his father. Gowin was keenly aware of the contrast between his father and mother:

My father lived the will of the Lord, as he saw it, and although he understood the Gospels in an intellectual sense, I felt the central meaning was often confused with the specific law. It was terrifying to me because the law could destroy the spirit. I was seven years old and I could see that, so I have no doubt that my fundamental character was already fixed by that time. My father frightened me with his theology, whereas my mother practiced patience and forgiveness. She was the influence in my life.

But Gowin did, however, inherit a fair share of his father's tenacity, and in turn overruled his own parents' desire that he enter the ministry. He recalls that when he received his master's degree in photography, his parents astonished him by their happiness and pride in his achievement. When questioned, his mother told him that they had been afraid he would become an artist!

Gowin's family had little interest in the arts apart from his mother's piano playing. At age twelve, Emmet began to draw. He had no instruction, but drew things he liked and copied from books. In 1955, Emmet's father moved to a new congregation on Chincoteague Island, Virginia, where Emmet began high school. He describes this time as one

1. Unless otherwise noted, quotations are taken from Martha Chahroudi's interviews with Emmet Gowin in 1989.

of incredible freedom. School was undemanding. The boys on the island grew up knowing that they would not need much education to make their living as fishermen, and in this environment Emmet found himself an indifferent student. He was instead enchanted by the study of nature and spent many after-school hours in the woods, often drawing what he had observed once he returned home. He credits Boy Scouting, in which he discovered "a small, organized literature of nature," for much of his general education. His understanding of creativity during these years came as much as anything from the Bible stories and images that were a part of his daily life and that taught him about the creation of meaning through the dualities of truth and fiction, a condition he later recognized in the nature of photographs.

Gowin loves to tell stories, and one that he most often repeats describes his first conscious discovery of a symbolic photograph. When he was about sixteen, waiting in the dentist's office, he came across Ansel Adams's photograph *Grass and Burnt Tree, Sierra Nevada*, in an issue of *Popular Photography*:

It was a picture of a burnt tree stump with a little grass sprouting up by it. I didn't recognize the photographer. I didn't recognize anything except that for me it had a kind of internalized equivalence to the very meaning of life. And I thought, "That's like Christ, that's like a resurrection, that is the cycle of life; things pass away and new life takes its place." I went home and asked my father for a camera, and I carried it around long enough so that I forgot what I was looking for. But eventually I found a burnt tree stump with young grass coming up in front of it, repeated the picture, and finished my one-month career as a photographer!

This single episode contains all of the seminal elements of Gowin's creative path: symbol, feeling, imitation, re-creation.

In 1957 Gowin, his sister, and his parents returned to Danville, where he finished high school and then attended business school for two years. As part of his training he worked part-time in a Sears printshop, making posters for store window displays. He soon found that he was not suited for the business world, and, after receiving his certificate in 1961, he enrolled in the graphic arts program at the Richmond Professional Institute (now Virginia Commonwealth University).

During his last year in business school, Emmet met Edith Morris at a Saturday night YWCA dance. He was impressed by her easygoing spon-

taneity and directness. She was a breath of fresh air to Emmet, attractive, popular, and a real alternative to the confining atmosphere of his own family. By the time he went away to school in Richmond, he knew their relationship was serious. He made frequent trips home to Danville, where Edith worked as a secretary, and they were married in the summer of 1964. Throughout the years, the stability and closeness of their marriage have consistently given Gowin enormous strength as well as the directedness to pursue his studies and career.

When Gowin began his courses at Richmond, he intended to concentrate on drawing and painting; however, photography was a required course for all freshmen enrolled in the graphic design curriculum, and Gowin remembers being among the few students who became deeply interested in the subject. By the end of his freshman year, he knew he would major in photography and transformed nearly every assignment into photographic terms. If he was given a typography project, he would photograph the type and make montaged prints. For a lettering project, he traced letters under an enlarger. If asked to design a package, he would incorporate a photograph. Gowin was fortunate that the head of his department, John Hilton, had gathered together a graphic arts faculty with strong backgrounds in the fine arts. Gowin admired and felt closest to the painters on the faculty: Richard Carlyon, Jewett Campbell, and James Bumgardner, who also respected and encouraged photography as a means of artistic expression.

During Gowin's first year at Richmond, someone showed him a copy of *The Family of Man*, the widely distributed catalogue of Edward Steichen's 1955 exhibition at The Museum of Modern Art in New York. As he turned the pages of the book, he began to respond to certain images, particularly those by Robert Frank and Henri Cartier-Bresson. He was surprised to recognize that the feeling in a photograph, while distinct to that image, was also connected to other images by the same maker. A photograph, he discovered, with all its limitations, could convey the photographer's own sensibility.

The photographs that Gowin was making in college were primarily inspired by Robert Frank's street photography. In the summer of 1963, Danville was the scene of many important civil rights confrontations. Gowin photographed these demonstrations after obtaining a press pass from the local weekly newspaper through the kindness of an editor who did not expect him to do any "real" reporting. At the same time he also

began photographing in black churches in North Carolina, where he found a religious spirit that impressed him deeply. He saw the pastors as artists who imaginatively led their congregations into a spiritual reality that transcended the hardships of their daily lives:

Art is the presence of something mysterious that transports you to a place where life takes on a clearness that it ordinarily lacks, a transparency, a vividness, a completeness. One's emotions are remade into something more whole and something holy. And I really believed these pastors were doing this. It was as good as any theater. They were doing what great actors do. They take you beyond the appearance of life. In the right frame of mind, you pass right through the superficial surface of things and see that behind it there is a reality that is infinite.

Gowin's senior thesis at Richmond was predicated upon these necessary co-ingredients of art and spirituality. Entitled *Concerning "America and Alfred Stieglitz" and Myself*, it fulfilled the assignment of producing one hundred copies of a book of original art, and contained fourteen of his photographs juxtaposed with seven pages of text reproduced from the 1934 Festschrift *America and Alfred Stieglitz*. The thesis was a kind of credo, establishing Gowin's kinship with the Stieglitz tradition of photography as art linked to experience and feeling. His photographs, made in 1963 and 1964, have the poignancy of life lived as the graceful unveiling of a mystery. In the pages that Gowin chose from *America and Alfred Stieglitz*, he first identified ideas about creativity that have stayed in his thinking to the present day, in particular this poem by D. H. Lawrence, which he often quotes:

The mystery of creation is the divine urge of creation,
but it is a great strange urge, it is not a Mind.
Even an artist knows that his work was never in his mind,
he could never have thought it before it happened.
A strange ache possessed him, and he entered the struggle,
and out of the struggle with his material, in the spell of the urge
his work took place, it came to pass, it stood up and saluted his mind.[2]

In 1965 Gowin graduated from the Richmond Professional Institute with a bachelor of fine arts degree and was accepted for graduate work

2. *The Complete Poems of D. H. Lawrence*, comp. and ed. Vivian de Sola Pinto and Warren Roberts (New York, 1971), p. 690.

at the Rhode Island School of Design in Providence, where he wanted to study with Harry Callahan. In 1963 Gowin had gone to New York to meet Robert Frank, and they spent a brief half-hour looking at Gowin's photographs. Frank was encouraging, even though Gowin suspects Frank must have smiled to himself at seeing images so much like his own. Frank advised him to go to graduate school only if he thought he wanted to teach and, if so, to study with Callahan.

Gowin was attracted by a quality in Callahan's images that he did not fully understand at the time, but that he now describes as "a poetry of feeling and intimacy and the revelation of a secret, unrecognized dimension in the commonplace." He recognized the potential for growth and discovery in his own work in coming to understand Callahan and his work, and in September 1965 he and Edith moved to Providence.

Callahan's approach to graduate school teaching was to send his students out to work on their own, without guidance or instruction, for the first month. Gowin remembers this as being an important and difficult time during which he felt very much alone in a new place. At first he experimented with the Callahan model of street portraiture of people moving through the city, lost in thought, encapsulated in a private space. But this time he was not to be satisfied with the process of imitation and re-creation that had guided him thus far.

A month after school had started, Gowin received his draft notice. Obviously concerned, he drove down to the draft board in Danville and decided to apply for classification as a noncombatant conscientious objector, which meant that he could be sent to Vietnam but would not bear arms. He was given this classification, but, as it happened, he did not receive an induction notice again until 1967, after the birth of his first son, Elijah. His status was changed again, however, as at that time men with families were not being drafted.

During his visit to the Danville draft board, Gowin stayed with Edith's family. He had with him a 4 x 5″ camera borrowed from the school and some film holders lent by Harry Callahan. The larger format camera was relatively new to him and he was not at all sure what kind of film was in the holders. Nevertheless, he began to photograph some of the children. One niece, Nancy, was particularly insistent that he include her, and she showed him her doll collection, hoping that he would make a picture of it. This photograph (page 24) was a turning

point for Gowin. He recalls that he responded very strongly to a sense of being guided toward a subject, of being invited to observe and encouraged by the willingness of the children to be photographed. An intimacy and spiritual connection with his subject that had been lost in Providence were regained.

On the way back to Rhode Island, Gowin stopped off in Richmond to print the Danville photographs in the kitchenette darkroom of one of his former painting teachers. He was tremendously excited with the results and knew that these half-dozen pictures were better than anything he had done previously. Gowin realized that he had made an important discovery: His own family was as significant a subject as were other people. By choosing as the center of his art something to which only he had access, he was in a privileged position:

I was wandering about in the world looking for an interesting place to be, when I realized that where I was was already interesting. There was something in family life, in the development of young minds, that was my subject: how it feels to be the child asking the parent for attention, and how it feels to be yourself, for the first time to recognize yourself as the parent rather than the child. My mental state had been that of a child, but I'd been drafted and I could no longer be a child, yet I wanted to look to children to understand this differentiation between what I used to be and what I am now. It was my realization of coming of age.

From then on, Gowin and Edith spent most holidays and a large part of each summer in Danville, where he photographed all the members of her extended family. Four generations of relatives lived in five houses on a rural cul-de-sac that formed a kind of family enclave. The adults all worked at Dan River Mills, the textile manufacturer. Emmet and Edith spent much of their time caring for the children, cooking, repairing the house, and generally helping out. Gowin describes the family's life style as "comfort in being." He felt at ease with them, experiencing a freedom and wholeness that came from love and acceptance, and he sensed that Edith's family was guided by "a God of nature —beneficent, creative, and manifest in love of people for each other." His photographs of them and of Edith are filled with his innocent fascination about the mystery of other lives that is part of the experience of intimacy.

While at the Rhode Island School of Design, Callahan's support was important to Gowin. Perhaps in a less deliberate way than in his imitation of Frank, Gowin owes to Callahan a tacit permission to photograph Edith and her family as Callahan had photographed his wife and their daughter. Callahan recognized the special bond between Emmet and Edith and how substantive that was for his work. He taught Gowin not to be easily satisfied and never to let anyone tell him what or how to photograph. Emmet honors Callahan as a "poet of feeling who taught by example."

Also during this time Gowin met Walker Evans, who, along with Frank, Callahan, and Frederick Sommer, he considers to be most important to his development as a photographer. A fellow student, Jim Dow, arranged to meet Evans in New York and invited Gowin to come along. Evans's photographs had a strong appeal for Gowin, who felt that "he had seized an elemental aspect of the exquisitely rendered photograph—that it was simultaneously evidence to an existing feature of reality, while its connotation pointed beyond the visible, the apparent, to a state of mind which was most accessible as a feeling."

At their meeting in New York, Gowin was eager to ask Evans if Lincoln Kirstein had been right when he wrote that Evans "saw Paris through . . . the great prints of [Eugène] Atget . . . and so equipped he could turn home to focus on contemporary America."[3] Evans told him that Kirstein had probably overstated the case, and that the whole question of influence was complicated and ambiguous. This was an important issue for Gowin, and he has spent years thinking about the subtleties of influence, invention, and originality in the creative process:

I think I have always developed stage by stage by accepting some model as very interesting. And in the earliest stages I often replicated the model. Eventually, I worked my way through it by simply coming up somewhere along side of the standard that it represented. And then it is always true that the coincidence of the many things that fit together to make a picture is singular. They occur only once. They never occur for you in quite the same way that they occur for someone else, so that in the tiny differences between them you can reemploy a model or strategy that someone else has used and still produce an original picture. Those things that do have a distinct life of their own strike me as being the things coming to you out of life itself.

3. Lincoln Kirstein, "Photographs in America: Walker Evans," in The Museum of Modern Art, New York, *Walker Evans: American Photographs* (New York, 1938), pp. 193–94.

The photographer who has had the greatest influence on Gowin's work and thinking is Frederick Sommer. A near recluse living in Arizona, Sommer is an artist and intellectual who expresses his ideas about art in poetic language. Gowin's first meeting with Sommer took place in the fall of 1967, when Gowin was just starting to teach photography at the Dayton Art Institute after having received his master of fine arts degree from Rhode Island that spring. Sommer had been invited to spend a few days with the students at Providence, and after his first lecture, Jim Dow called to tell Gowin how remarkable it was to hear Sommer speak, and urged him to come to Providence if at all possible. Gowin drove through the night from Ohio with one of his students, arriving minutes before Sommer's next lecture began. Callahan arranged for Gowin to come to his house to meet with Sommer the next morning, when they were to have an hour together before anyone else arrived. They had an immediate rapport. Gowin, who had heard that Sommer actually bleached his photographs, told him that what he most wanted to learn was how to apply the same process to his own work. Sommer, who from the first was impressed by Gowin's personality, then described his technique for bleaching a print. With this encounter the two men thus began their pattern of frequent conversations, yearly meetings, and occasional joint travels that continues to the present.

Before they met, Gowin had known of Sommer through his photographs and writings published in *Aperture* magazine in the early 1960s. He responded strongly to Sommer's images and poems, which for Gowin were expressions that implied an eclectic and imaginative mind that could stimulate his own thinking. Over the years, Gowin was to discover in Sommer's ideas a personal cosmology that connected the practice of making art with a larger pursuit integrating history, physics, poetry, music, and philosophy. Sommer, and the wide range of sources upon which he drew, presented Gowin with an approach to life and art that was based not on theology but on poetic logic—"the spirit, not the law," as Gowin describes it.

Sommer often shared his latest reading with Gowin, appearing with a new book or a reading list in hand. One of the first of these books, Werner Heisenberg's *Physics and Beyond: Encounters and Conversations* (New York, 1971), opened up the realm of the sciences to Gowin:

I began in Chapter 6, "Fresh Fields," and I didn't read long before I came to a sense that I would not perceive the world in quite the same way again. I find that I'm in harmony with the physicists, the scientists. I find them to be the most poetic people of our age. I feel a great kinship with the values of the scientist-writers, with Werner Heisenberg, Niels Bohr, Jacob Bronowski, and Heinz Pagels. In each case, my knowledge of their work is an incomplete thing, but I feel the most tender language is coming from them. Perhaps I'm at fault for not having read enough in the arts, but I rarely find in the history of art the subject of the whole of life expressed in such a nonaggressive fashion. I require a non-aggressive approach to positive solutions that have as their subject the unity of life.

Sommer also inspired Gowin to perfect his printing of his photographs. For Gowin, Sommer's prints "set a standard of respect for the medium, respect for the materials, and conviction as to what the materials were capable of doing." Sommer freely shared with Gowin his knowledge of photographic equipment, materials, chemicals, and printing techniques, and Gowin often repeats Sommer's admonition to him: "Don't let anyone talk you out of physical splendor." Over the years, Gowin has developed methods of printing born from patient experimentation and a love of craft. His background in painting and drawing taught him that there are many solutions to making a finished work of art and that the instantaneous nature of photography need not limit the character of the final print, which he often builds as if it were a drawing to achieve the most satisfying integration of elements:

The mystery of a beautiful photograph really is revealed when nothing is obscured. We recognize that nothing has been withheld from us, so that we must complete its meaning. We are returned, it seems directly, to the sense and smell of its origin. . . . A complete print is simply a fixed set of relationships, which accommodates its parts as well as our feelings. Clusters of stars in the sky are formed by us into constellations. Perhaps I feel that this constellation has enough stars, and doesn't need any more. This grouping is complete. It feels right. Feeling, alone, tells us when a print is complete.[4]

During his years in Dayton, Gowin's work began to be recognized. He had his first solo show in 1968 at the Museum of the Dayton Art

4. Gowin quoted in Jain Kelly, ed., *Darkroom 2* (New York, 1978), p. 43.

Institute. In 1970 eight of his photographs were published in the British periodical *Album*,[5] an exhibition of his work was held at the George Eastman House in Rochester, and the Fogg Art Museum at Harvard University made the first museum purchase of his photographs. The following year Peter Bunnell, who was later to become a close friend and colleague at Princeton University, organized an exhibition of the work of Gowin and Robert Adams at The Museum of Modern Art, and *Aperture* published a portfolio of fifteen of Gowin's images.[6] Since this early acceptance of his work, Gowin's career as a photographer has advanced through channels that are more personal than public. Teaching, lecturing, and giving workshops, to which he is dedicated and which suit his personality, have provided his primary connections with the field. Exhibitions and publications have come about through invitation rather than self-promotion. The 1976 monograph published by Alfred A. Knopf in association with Light Gallery gave Gowin his widest public exposure.[7] This was followed by an exhibition and catalogue organized by Peter Bunnell for The Corcoran Gallery of Art in 1983,[8] and the publication and exhibition of his photographs of Petra by Pace/MacGill Gallery in 1986.[9]

In 1971 Gowin left the Dayton Art Institute and the family moved to Newtown, Pennsylvania, where he accepted a teaching position at Bucks County Community College that he held until 1973, when he was invited by Princeton University to teach photography in the Visual Arts Program. As always, the Gowins returned to Danville whenever they could, but the photographs he was making there began to take on a different character, expanding the intimate frame of reference of the family to include more of the environment in which they lived. This change was presaged by Gowin's use of the circular image, which he had discovered by chance in 1967. He had an Eastman 2D 8 x 10″ view camera without a lens, and he fitted it with a 90-mm Angulon lens

5. "Emmet Gowin," *Album*, no. 5 (June 1970), pp. 40–48.

6. "Photographs/Emmet Gowin," *Aperture*, vol. 16, no. 2 (1971), n.p.

7. *Emmet Gowin: Photographs* (New York, 1976).

8. Peter C. Bunnell, *Emmet Gowin: Photographs 1966–1983* (Washington, D.C., 1983); catalogue of an exhibition held at The Corcoran Gallery of Art, Washington, D.C. (September 17–November 13, 1983).

9. Emmet Gowin, *Petra: In the Hashemite Kingdom of Jordan* (New York, 1986); published in conjunction with an exhibition held at Pace/MacGill Gallery, New York (January 9–February 15, 1986).

made for a 4 x 5″ camera. The 8 x 10″ film was nearly large enough to encompass the entire projected circle of image that reached it through the lens. At first Gowin cut the circular image down to a standard rectangle, but very soon grew to appreciate the qualities of the circle: "Eventually I realized that such a lens contributed to a particular description of space and that the circle itself was already a powerful form. Accepting the entire circle, what the camera had made, was important to me. It involved a recognition of the inherent nature of things."

In the early 1970s new places and experiences were presenting themselves as subjects for Gowin's photographs. In 1972 the family traveled to England, Scotland, and Ireland, where Gowin made quite a number of successful photographs—circular "landscapes" of intimate spaces (pages 47, 51–53). These have the same qualities of intimacy and mystery as the photographs of Edith's family and have always been considered an extension of that work. Like peepholes or kaleidoscopes, Gowin's circular images enclose spaces where he can both accept more of the context of the world and at the same time allow a childlike imagination to thrive.

Before the Gowins left on their trip to the British Isles in 1972, which was the first of many visits to Europe, they considered their plans in light of the condition of Edith's grandmother, Rennie Booher, who was ninety-seven years old. She did in fact become ill and died shortly after their return. In Danville for her funeral, Gowin very much wanted to photograph Rennie Booher in her coffin, but one aunt was strongly opposed to the idea. He had intended to abide by the aunt's wishes, but standing beside the coffin, with no one else around, he knew he had to make a picture and exposed one side of a film holder. When he developed the film, he saw that he had accidentally loaded an exposed sheet of film from his work in England into the film holder he had used to photograph Rennie Booher, thus double-exposing her death portrait with a detail of the Avebury stone circle (page 57). The conjunction of the two images—the deceased matriarch of his wife's family and the megalithic burial monument—was the kind of fortuitous event that he could never have planned. This image, literally and emotionally, marked his progress away from the Danville family pictures.

Another image that proved to be a landmark in Gowin's development as a photographer was *View of Rennie Booher's House*, a circular

landscape made in 1973 (page 55). Once again, the children in the family had pointed the way for a discovery, when, in the fall of that year, they had built a tree house. By the time Gowin arrived in Danville for Christmas, a board had fallen from one wall. He climbed up to the tree house with his camera and saw through the wall an entrancing view of the house that had belonged to Rennie Booher. For Gowin, this was still a time when everything about Danville cried out to be photographed, and yet, when he looked out of the tree house, he knew that this situation could not continue forever. He saw, gathered within this landscape, the experience of past years giving force to the necessity for change.

By 1973 the family in Danville was irretrievably altered. Along with Rennie Booher, two of the older men in the family, Edith's uncles Raymond Booher and Willie Cooper, had died. At age thirty-two, Gowin could no longer stand aside as the innocent observer in family matters, such as conflicts between the children, that required an active adult hand. The sheltered vantage point that had been necessary for his photography in Danville was disappearing. At the same time and increasingly from 1974, in his photographs of Edith, Gowin was becoming less concerned with the context of her family and more involved with the symbolic relationship between the female body and the earth (pages 49, 89–91).

From 1973 to 1980, all of Gowin's important landscape work was done in Europe. On his second trip, in 1973, he traveled in Italy, where he had friends and felt very much at home. As he recalls, "It didn't take me very long to realize that every spot on earth was an intimate space to somebody, that every landscape was a place where someone had positioned their hearts and taken in the long view that had penetrated to the core of their very being." The sense of intimacy that had been so important to him with the family pictures extended into his responsiveness to the Italian landscape. When, on the other hand, Emmet, Edith, and Elijah traveled to Peru for six weeks in 1975 on a Guggenheim Fellowship, he had difficulty relating to that country except as a tourist, and, returning temporarily to the 35-mm format, was unable to produce any meaningful images. He says of that period, "Not only were life and travel difficult in Peru, but I quickly realized that in order to have the intimacy I had hoped for, I would need to be reborn a Peruvian."

It was also in 1975 that the Gowins, with their new son Isaac, did their most extensive traveling in Europe, visiting Great Britain, Germany, France, Greece, Yugoslavia, and Italy. Gowin was again especially drawn to the cultivated hillside gardens of Italy, which he began to see as earth sculptures that had a richness of tradition and an uncontrived yet sophisticated natural reality, "a beautiful elaborate tapestry of geometries that had been laid out as a plan, as an enterprise, as a structure to optimize growth and productivity." To convey this complex, compressed "tapestry," Gowin required a different format from the circle, and for this he turned to the longer lenses for his 8 x 10″ camera that he had used successfully for still lifes.

The Hint That Is a Garden: Siena, Italy, 1975 (page 63), which Gowin dedicated to Sommer, was the first image in the series of photographs he now refers to as "working landscapes," made primarily in Italy and Ireland. These are images of the cultivated gardens of necessity and survival, functional family enclosures, intimate settings for human endeavor, which he likens in spirit to the early imaginative drawings of fecund nature by the nineteenth-century English artist Samuel Palmer and prints by the seventeenth-century Dutch artist Hercules Seghers. Gowin's identification with Seghers is also apparent in his photographs that followed the "working landscapes." Seghers's imagery is divided between two extremes: one, naturalistic views of farmlands, fields, and distant cities; and the other, imaginary views of deserted valleys surrounded by fantastic rock formations. It is to these latter images, with their sense of foreboding and disaster, that Gowin's photographs of Mount St. Helens (pages 77—87) and Petra (pages 93–101), at once real and fantastic landscapes formed by natural forces paradoxically destructive and creative, are strangely attuned.

In 1980, the Seattle Arts Commission awarded Gowin a fellowship to photograph in the state of Washington, where he arrived in late June. He hoped to photograph at Mount St. Helens, which had erupted in May, but it was still nearly impossible to enter the restricted ten-mile radius of the volcano. Joined by his family, Gowin instead spent the next several weeks traveling through the state, photographing agricultural areas, the clear-cut forest industry, and the Olympic Peninsula rain forest. In Seattle, he tried photographing the city from the roof of an old skyscraper. In retrospect, however, he realized that only two images made during that time sustained his interest.

Toward the end of his stay in Washington, Gowin finally found a local pilot, daily flying scientists over Mount St. Helens, who obtained

permission to take him over the restricted zone. Gowin had brought with him a camera he had purchased the previous winter thinking that he might use it to make self-portraits. It was, fortuitously, perfect for aerial photography, since it was weighted to minimize vibrations and had a prism that gave him the best angle of view from the plane window. During his second flight, close to evening, he made the whole series of pictures that he would submit to the Seattle Arts Commission at the end of the project.

Gowin's experience in the air had convinced him that he needed to see the landscape from the ground as well. He was extremely fortunate to meet William Hauser, head of the Photographic Section of the U S. Forest Service, who, by coincidence, was at the administrative office of the Gifford Pinchot Forest when Gowin was explaining his project and trying to get authorization to land in the restricted zone around the volcano. Hauser, overhearing him, took up his cause and helped him to obtain the necessary permission. After that, Gowin returned to Mount St. Helens to photograph the processes of change and regrowth in the spring and fall of every year through the spring of 1984.

The series of images of Mount St. Helens mark the beginning of Gowin's interest in photography as a kind of subjective science. Unlike the cultivated landscapes he had photographed in Europe, the realities of the volcano required an acceptance of the impersonal aspect of nature and a recognition of how little control human beings actually have over certain aspects of nature, which Gowin illustrates with *Scientific American*'s comparison of the force of the eruption of Mount St. Helens to that of 27,000 Hiroshima-type atomic bombs exploding at one-second intervals for nine hours.[10] In working around the volcano, Gowin became interested in learning about the earth and finding explanations for the observable facts of his images. While the act of photographing involved an absolute, sensual surrender to confronted reality, viewing the finished prints involved Gowin in a process of self-education. This process was and is one of intuitive deduction from Gowin's scrutiny of the images and his experience of the site, frequently but not always verified by reading or talking with scientists.

For example, much of the interest in a number of his aerial photographs of Mount St. Helens (page 83) lies in the beautiful and mysterious etching of the dark lines that trace through the landscape. Gowin surmised that these lines distinguish the boundary between the volcanic ash and the rebuilding glacier on the mountainside, which was made visible by melting snow seeping into the ash during the heat of the day. At night the boundary line would freeze again to invisibility. It was important for Gowin to understand this phenomenon, for it increased his personal connection with the images both intellectually and emotionally, and provided an expanded context for their symbolic meaning. Geological factors also explained the tessellated beauty of one of his later aerial photographs in which a field of wheat, ready to be harvested, is traversed by lines of glowing light (page 126). The field stands on limestone, which, Gowin reasoned, fractures geometrically. The wheat grows slightly taller over the fertile fractures, where more soil and moisture accumulate. From the air at sunset the difference in height appears as an exquisitely luminous pattern. This quite literally embodies an idea that Gowin, paraphrasing James Joyce, frequently applies to his images: "the radiance of the invisible which emanates through the visible."

In 1982 the Gowins were invited to visit the Hashemite Kingdom of Jordan by Queen Noor al-Hussein, the wife of King Hussein. She had been a student in Gowin's photography class in her senior year at Princeton in 1974. She particularly wanted him to see the ancient city of Petra, which had been the capital of the Nabataean people between the early fourth century B.C. and the fourth century A.D. It was a thriving, sophisticated, urbanized center of trade, securely sheltered by high cliffs. Then, in the early evening of May 19, A.D. 363, a powerful earthquake virtually destroyed the city. Petra partially survived for two more centuries until another major earthquake occurred, after which it was buried by centuries of drifting sands. It was rediscovered in 1812 by the Swiss explorer Johann Ludwig Burckhardt and is still in process of being unearthed. Gowin photographed there for two days in 1982, returning in November 1983 and July 1985 to concentrate on photographing the tombs, which are its principal architectural structures. In these silent, still images of a lost civilization, a palpable sense of man's presence, the echoes of activity and enterprise, come alive. With their blank skies and their magnificent tonalities, they are reminiscent of nineteenth-century photographic landscapes, embodying a sense of sublime awe in the face of tremendous natural forces.

10. Robert Decker and Barbara Decker, "The Eruptions of Mount St. Helens," *Scientific American*, vol. 244, no. 3 (March 1981), p. 68.

At present Gowin's attention is shifting from the landscape of natural cataclysms to the earth as changed by man. Two incidents sparked his interest in the man-made landscape. In 1983, while flying from Washington to Colorado, he saw tire tracks arrayed radially around certain points on a desert plain. At the time he could not make sense of this configuration, but upon reflection realized that the tracks might indicate the site of an underground missile silo. This first contact with the nuclear landscape made an impression on him that stayed in his mind. Then, in 1986, having returned to Mount St. Helens to photograph inside the crater only to be thwarted by rainy weather, he instead flew over the abandoned city site of Old Hanford on the Hanford Nuclear Reservation in Washington, which in the 1940s was the site of the first two nuclear reactors built to make the plutonium to trigger the atomic bomb. It was here that he made his first aerial photographs of the nuclear landscape.

Since that time, Gowin has taken every opportunity to educate himself to the weighty reality of the contemporary, humanly shaped landscape. He began to read about the history of nuclear power, and was especially interested in Richard Rhodes's Pulitzer-Prize-winning book, *The Making of the Atomic Bomb* (New York, 1986), which, like many of the sources that inspire him, he frequently took to classes to read to his students.

In North Dakota, local peace workers supplied him with one of their "Nuclear Heartland" maps of the approximately one thousand nuclear missile silos in the United States. These silos, as well as other sites of ecological importance such as water treatment plants and open pit mines and their tailings, are now the subjects of his aerial photographs and are among his most constant concerns:

It is clear to me that even before 1986, when I first saw Hanford or read Rhodes's astonishing book, I was making photographs from within the nuclear age. It is also clear to me that more than any one single factor is involved. Even if we could turn back the nuclear clock, the attitude that humankind has had toward nature is based largely on dominance, ownership, and a concept of rights founded on a misunderstanding. We have believed that we could do as we wished with the earth without substantially affecting ourselves.

These photographs of the tracings of human beings reveal mankind not as a nurturer but as a blind and godlike power. Even his latest aerial agricultural landscapes made on route to nuclear sites have a magnificent indifference to human scale. For Gowin, confrontation of man's part in the creation of ecological problems would seem to require the most transcendental point of view, and as his subjects have become more difficult and frightening, he has created his lushest and most seductive prints.

In many ways the progress of Gowin's work mirrors his personal maturation as someone facing increasingly greater issues from a decreasingly protected vantage point. Equally, Gowin can be seen to be an artist centered in a space of sensibility, looking out upon an increasingly shrinking world. Throughout his work, from the family images to the nuclear landscapes, his passionate concern for discovering the interrelationships between people and the earth can be felt:

We are products of nature. We are nature's consciousness and awareness, the custodians of this planet. If Heinz Pagels is right, and all matter in the universe came about through the thermonuclear burning of hydrogen, and all elements heavier than hydrogen are a progressive evolution of chemical compounds, and the earth and water and all the elements that comprise our body, everything we see and touch, are all just stardust, we can't think of ourselves as anything but the by-products and custodians of this earth. A nuclear reaction was our birthplace as well as what threatens our extinction. Our consciousness has come to a point where we can do things to nature. We can begin to control it to such a degree that we can (and must) make decisions about what becomes of it. We can exploit it and dominate it or learn to think in new ways. We begin as the intimate person that clings to our mother's breast, and our conception of the world is that interrelationship. Our safety depends on that mother. And now I'm beginning to see that there's a mother larger than the human mother and it's the earth; if we don't take care of that we will have lost everything.[11]

MARTHA CHAHROUDI

11. Interview with Patricia Leighten at the Delaware Art Museum, Wilmington, May 7, 1989.

What we do to the Earth we do to ourselves

I see my work as several strands of a single thread. My evolution from a single-mindedness, centered on the family and its intimate surroundings, to a larger awareness of the landscape and an acceptance of the nuclear age was a natural and necessary step for me. By backing away in physical and mental space, I could see that our family not only belonged on and was sustained by the land, but that the vegetable and biological earth had made us all. We had our beginnings in the dreams of stars. Over time we had become the thoughts of matter as well as its awareness.

These realizations constituted a coming of age for me. I could never again think of who we were without thinking of where we were. The physical, spiritual, and environmental shape of that whereness was as profoundly given and important to us as who our parents had been.

In my work I observe that the edge between reality and shape, metaphor and meaning, has become uncertain to a point nearing duality. Our sight, it seems, is shaded by desire and bent by the arrogance of what we want or want to believe. Such thinking affects us all. Still, I want to go out into the world away from the familiar and bear witness to what I find, while I educate myself and my emotions.

Just as we can never outgrow our connectedness to the family, so all art, no matter how abstract, will have its roots in the story of the unfolding of life. I also realize now that my feelings and my concerns will always hold these same people in the heart of my unconscious mind. However, as one who backs away to see the world in a greater wholeness, the visage of that dear and familiar face, the loved one, diminishes to the infinite smallness of a speck. My task, and perhaps our task collectively, laying aside appearances, is to love that indiscernible point of life as the very being of our heart's desire, as imaginatively and vividly as if it were ourselves.

EMMET GOWIN

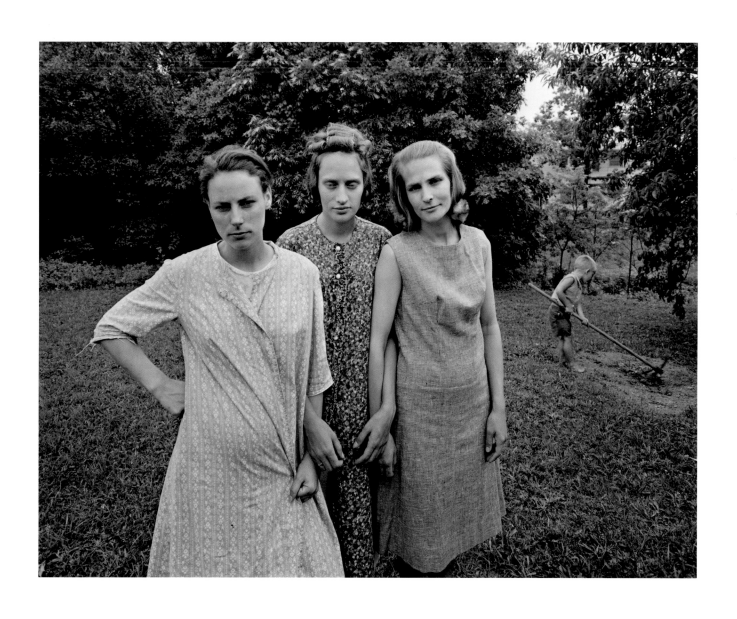

Edith, Ruth, and Mae, Danville, Virginia, 1967

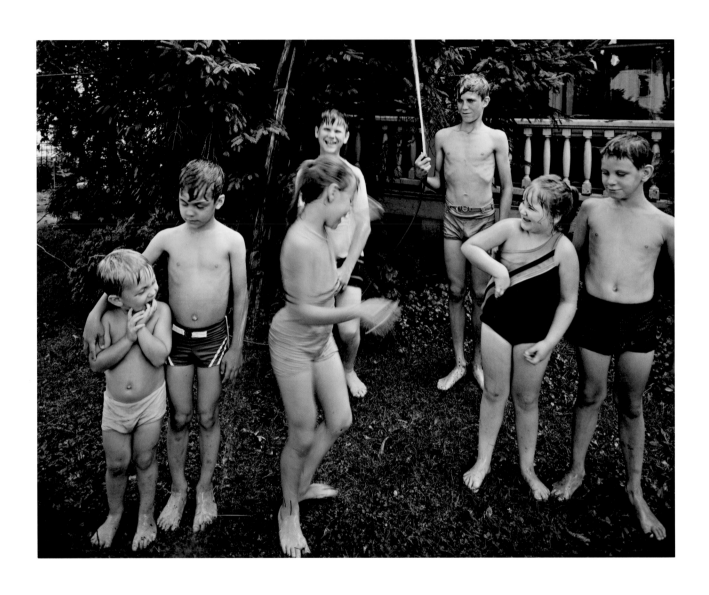

Children Playing, Dayton, Ohio, 1968

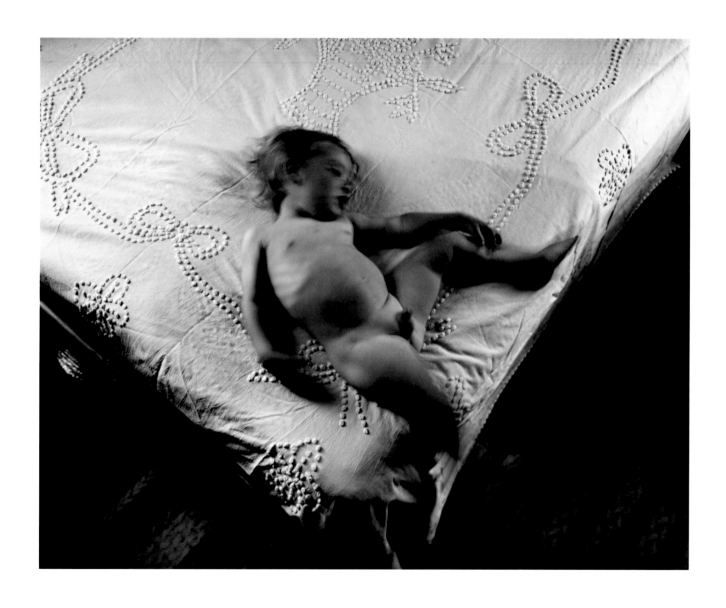

Elijah, Danville, Virginia, 1968

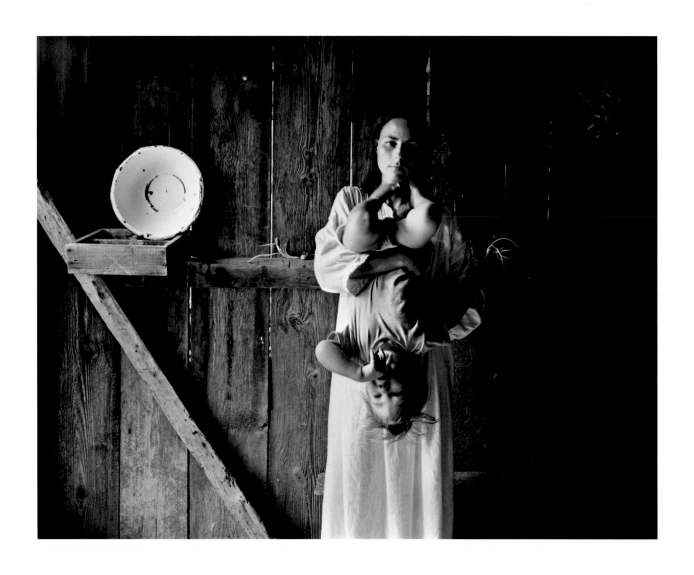

Edith and Elijah, Danville, Virginia, 1968

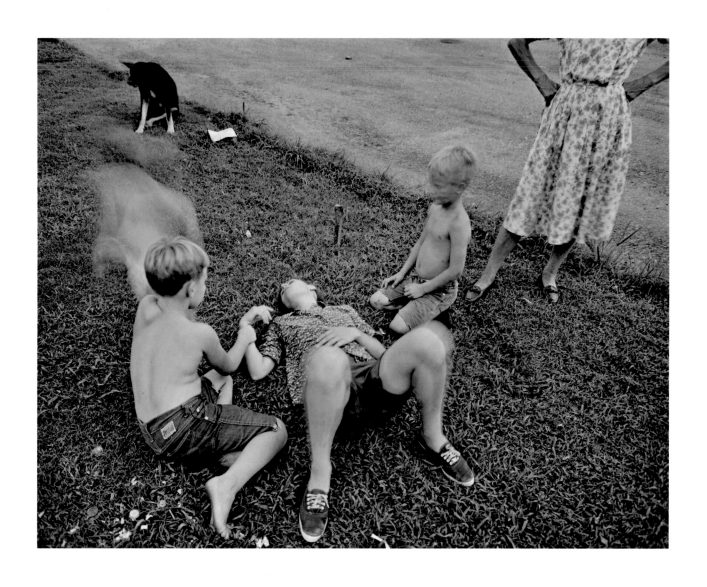

Family, Danville, Virginia, 1967

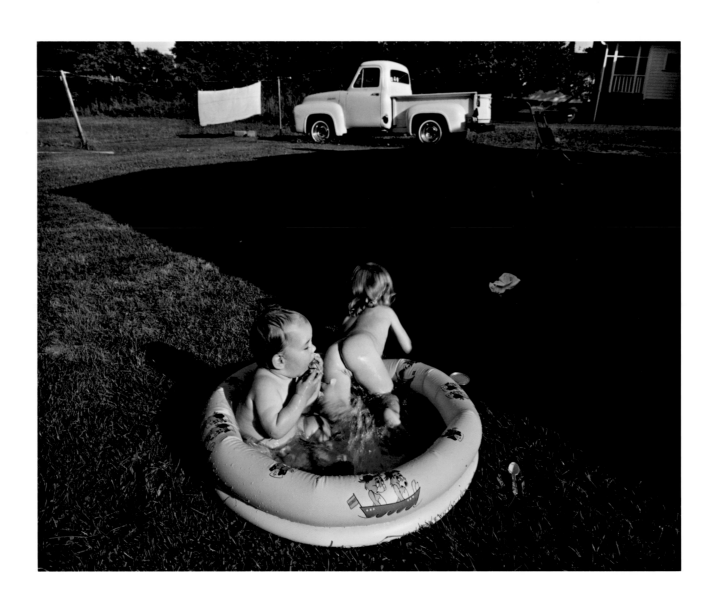

Elijah and Donna Jo, Danville, Virginia, 1968

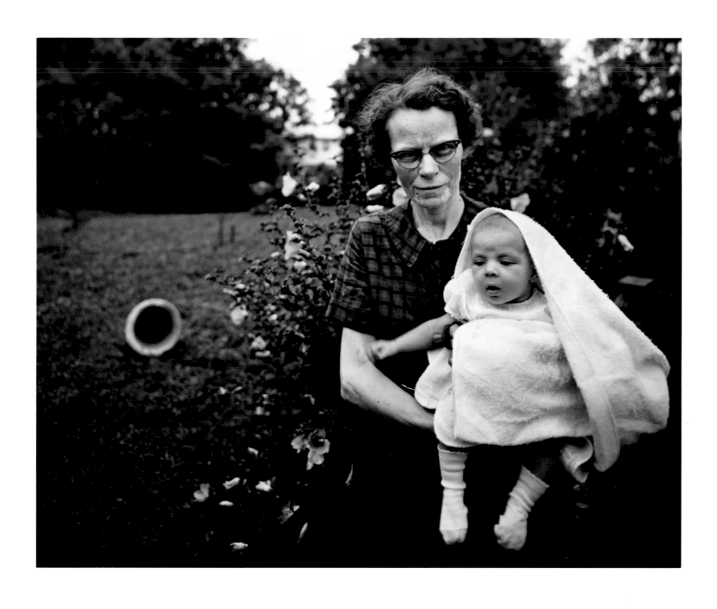

Maggie and Donna Jo, Danville, Virginia, 1966

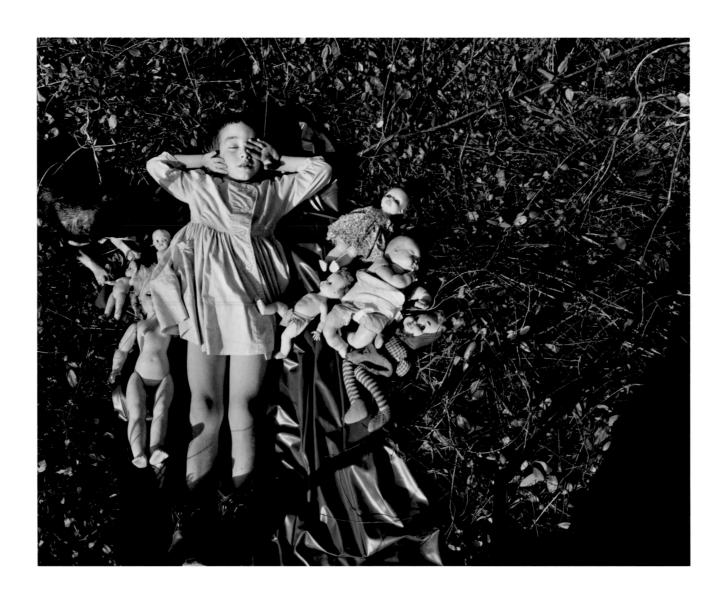

Nancy, Danville, Virginia, 1965

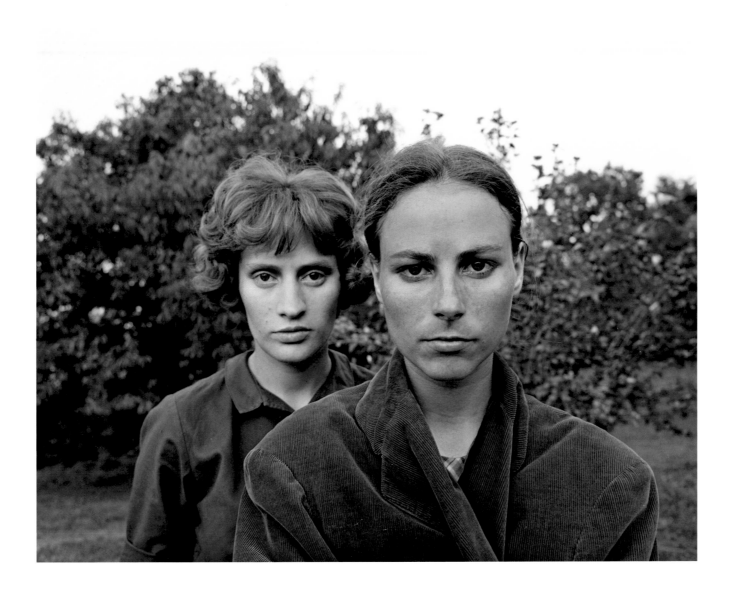

Ruth and Edith, Danville, Virginia, 1966

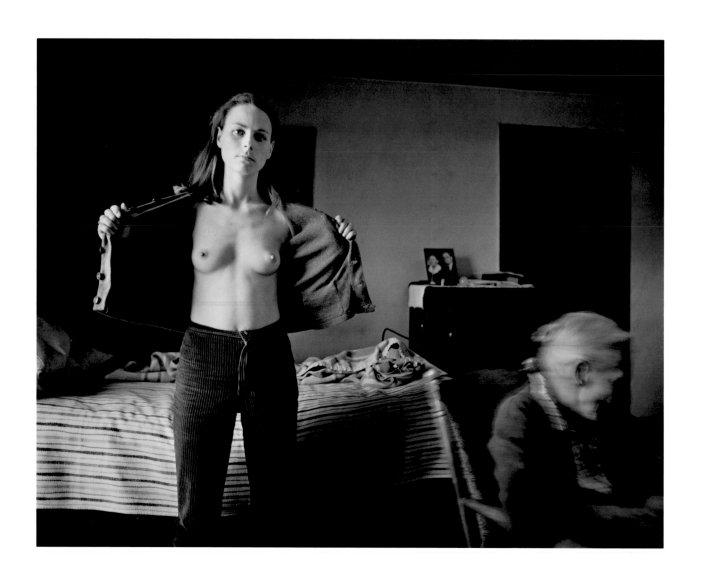

Edith and Rennie Booher, Danville, Virginia, 1970

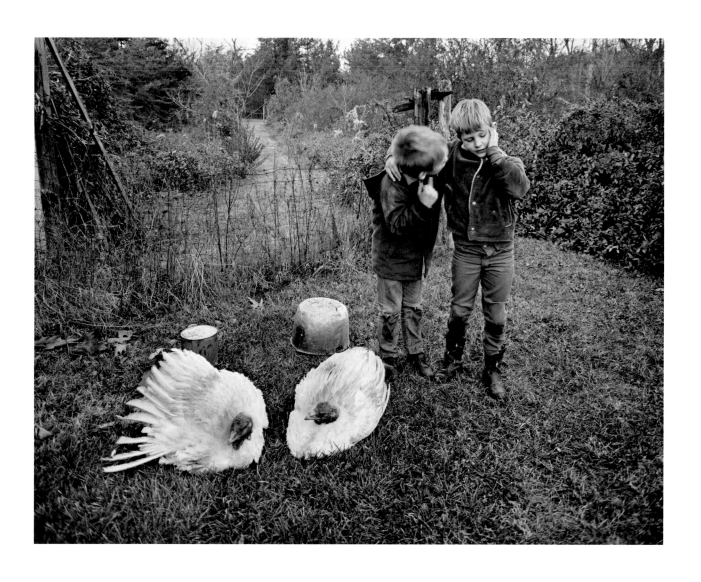

Barry, Dwayne, and Turkeys, Danville, Virginia, 1970

My heart rouses
 thinking to bring you news
 of something
that concerns you
 and concerns many men. Look at
 what passes for the new.
You will not find it there but in
 despised poems.
 It is difficult
to get the news from poems
 yet men die miserably every day
 for lack
of what is found there.
 Hear me out
 for I too am concerned
and every man
 who wants to die at peace in his bed
 besides.

WILLIAM CARLOS WILLIAMS
From "Asphodel, That Greeny Flower"

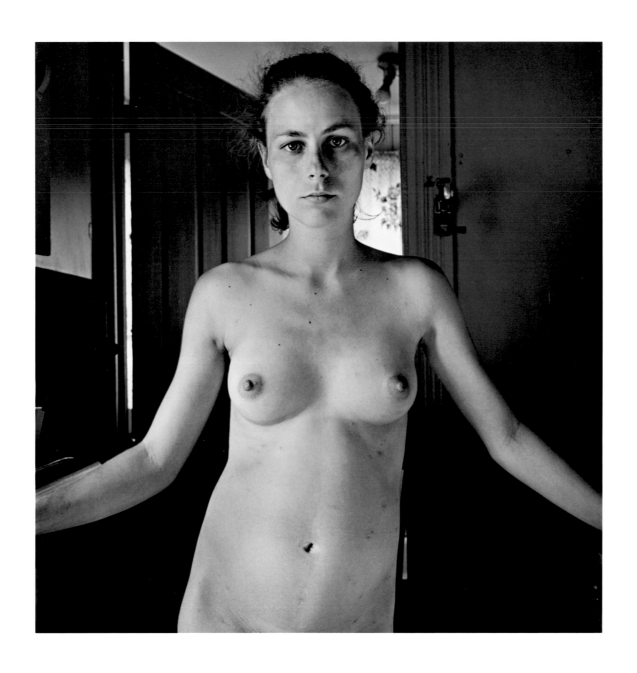

Edith, Danville, Virginia, 1967

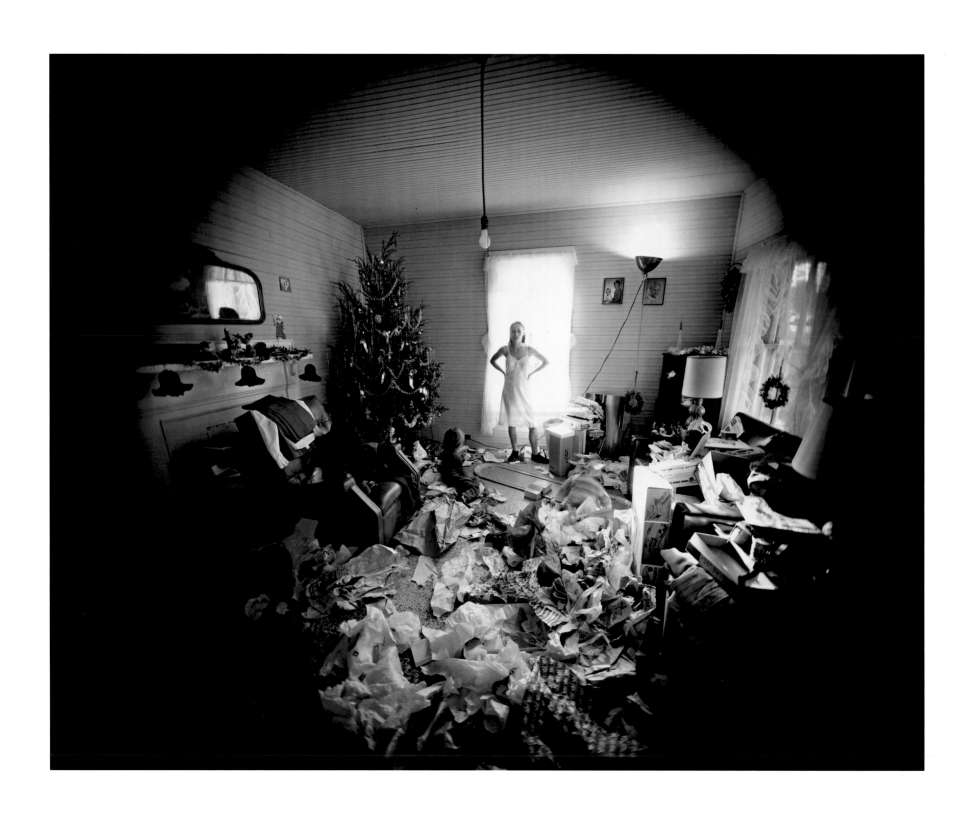

Edith, Christmas, Danville, Virginia, 1971

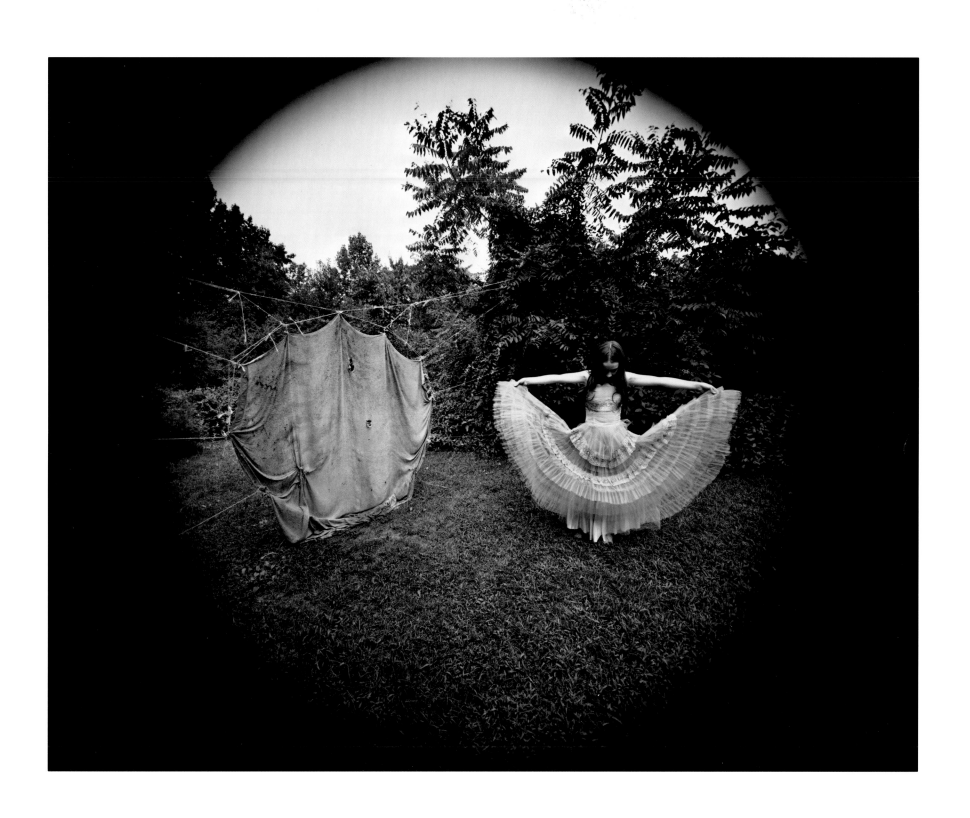

Nancy and Twine Construction, Danville, Virginia, 1971

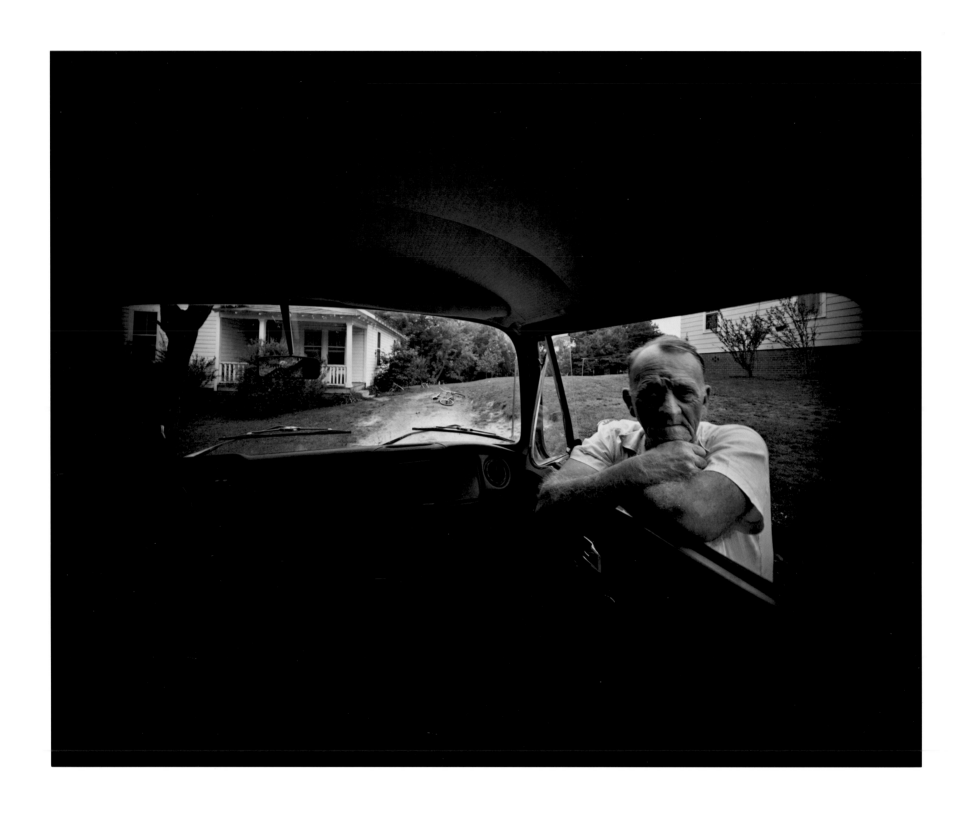

Willie Cooper, Danville, Virginia, 1970

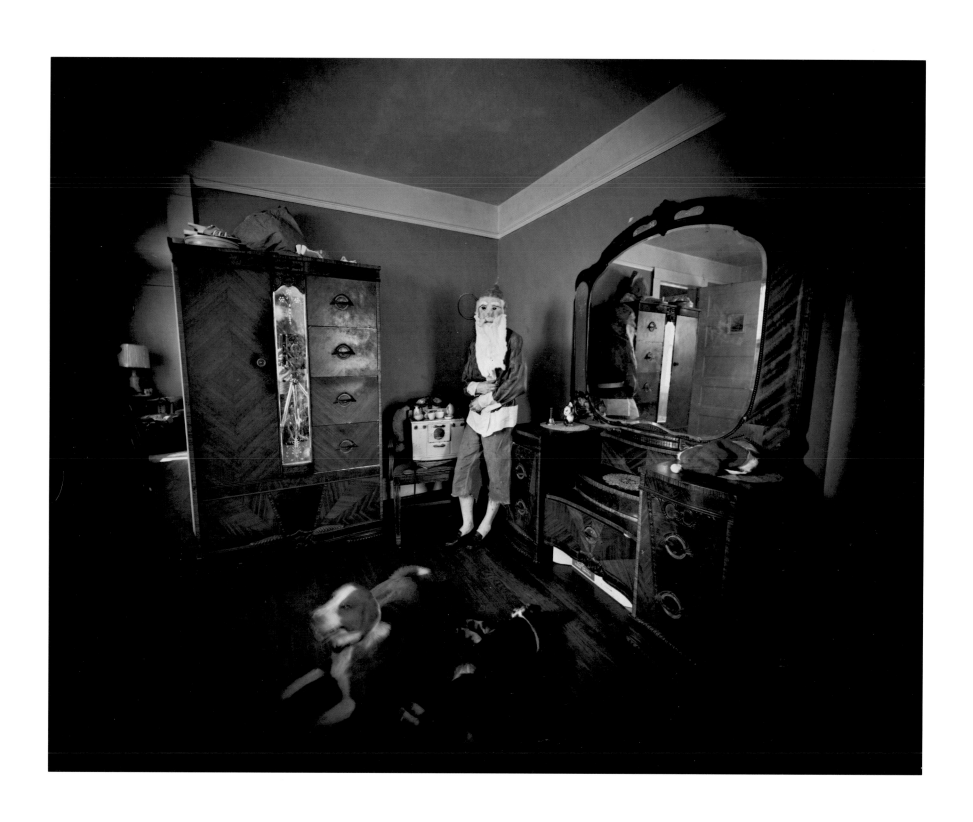

Maggie as Santa, Danville, Virginia, 1970

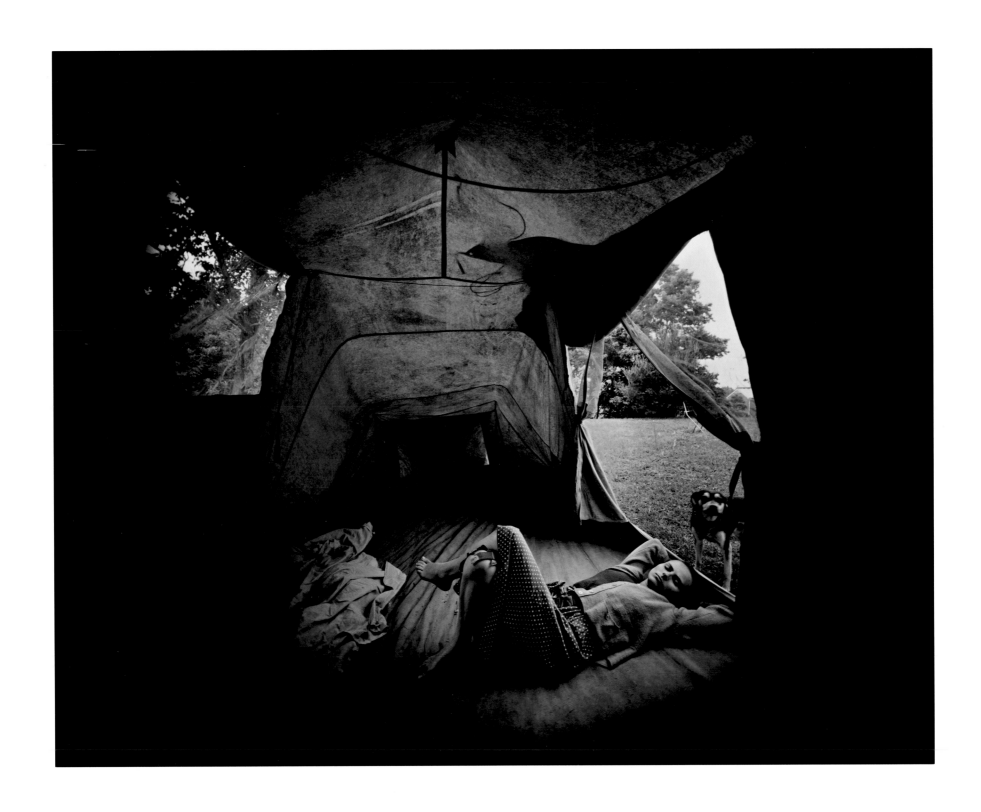

Edith, Danville, Virginia, 1970

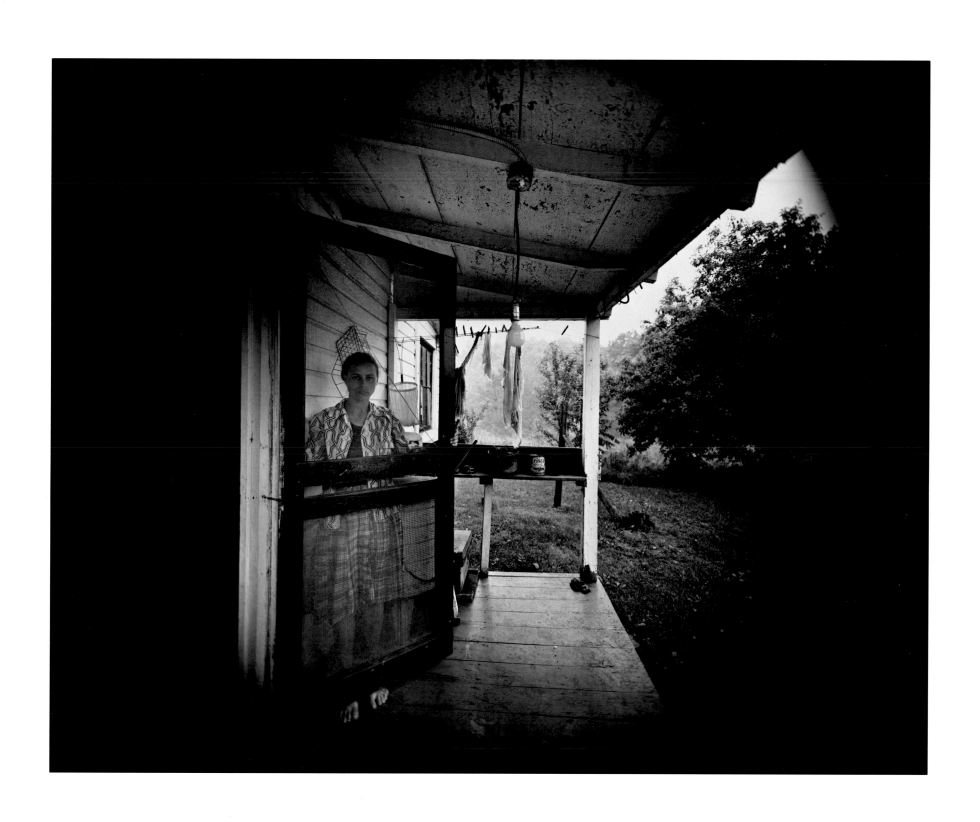

Edith, Danville, Virginia, 1971

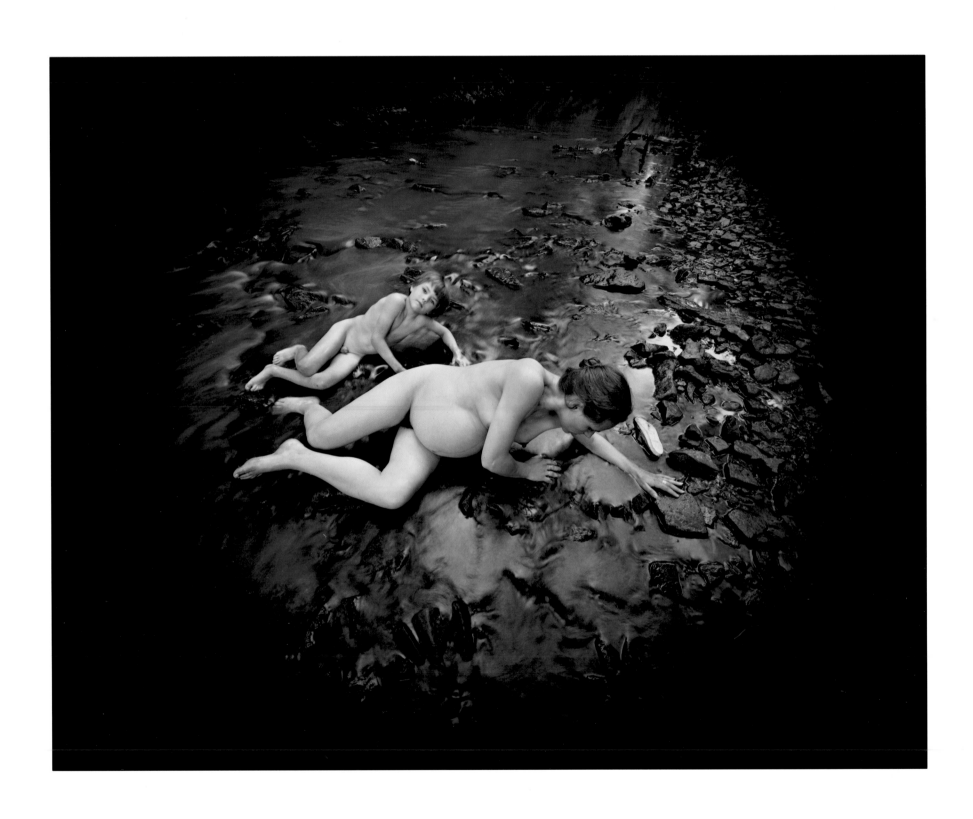

Edith and Elijah, Newtown, Pennsylvania, 1974

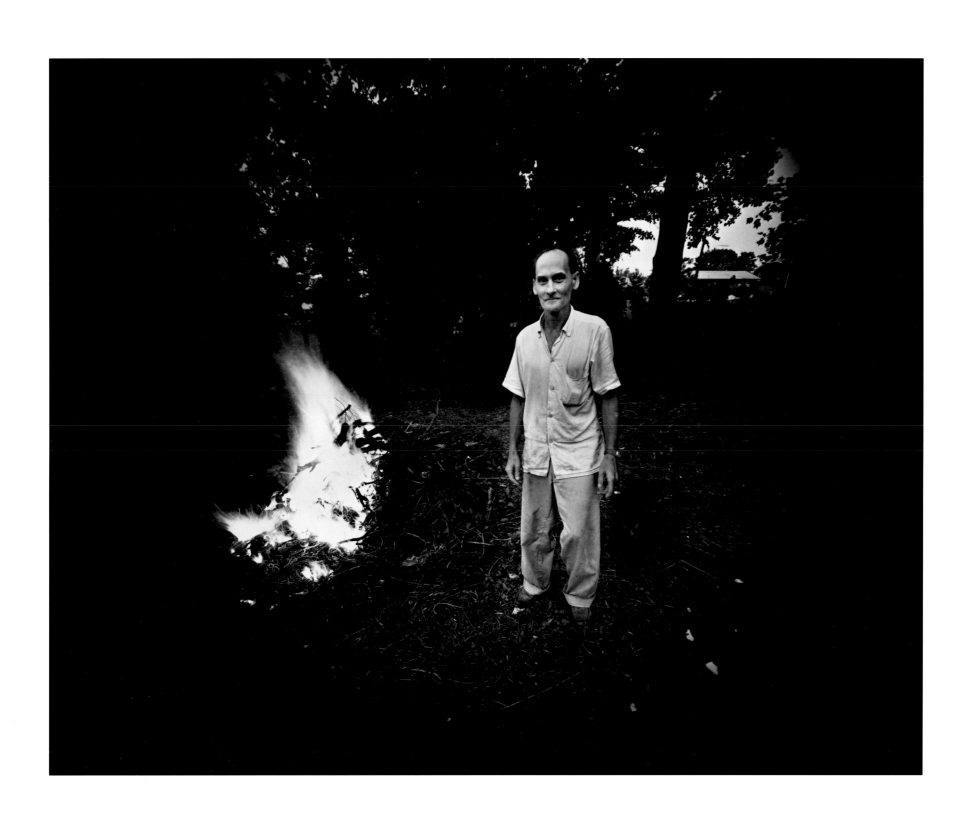

Ralph and Fire, Danville, Virginia, 1970

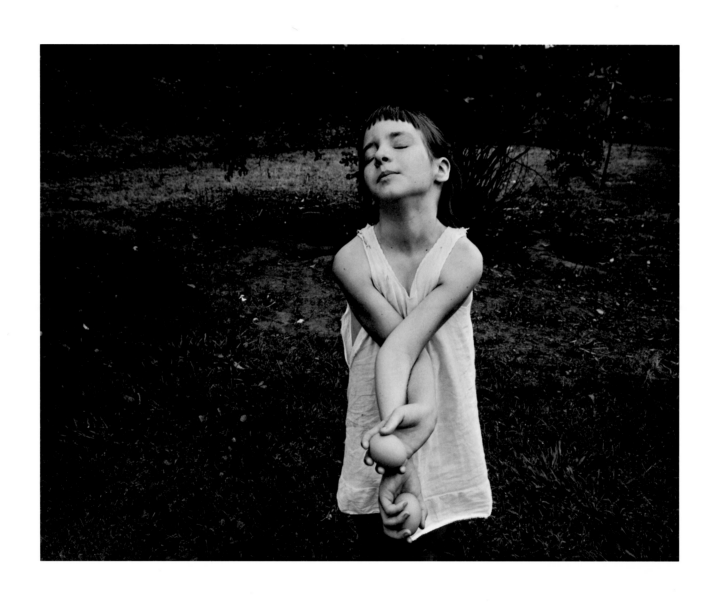

38

Nancy, Danville, Virginia, 1969

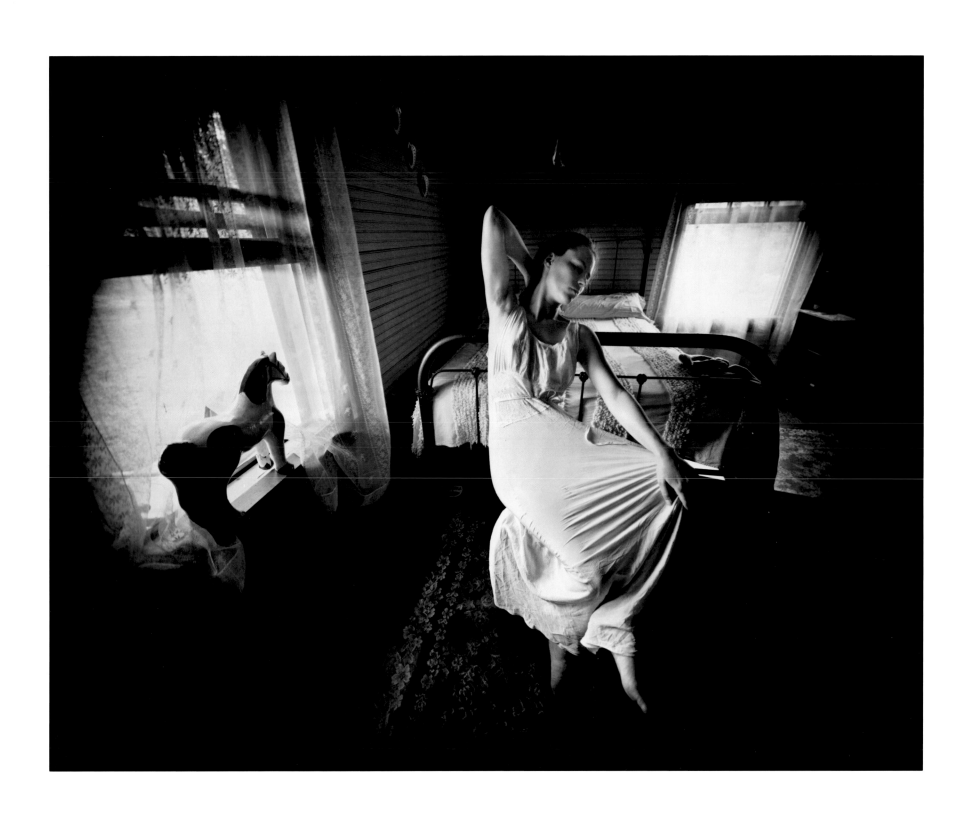

Edith, Danville, Virginia, 1971

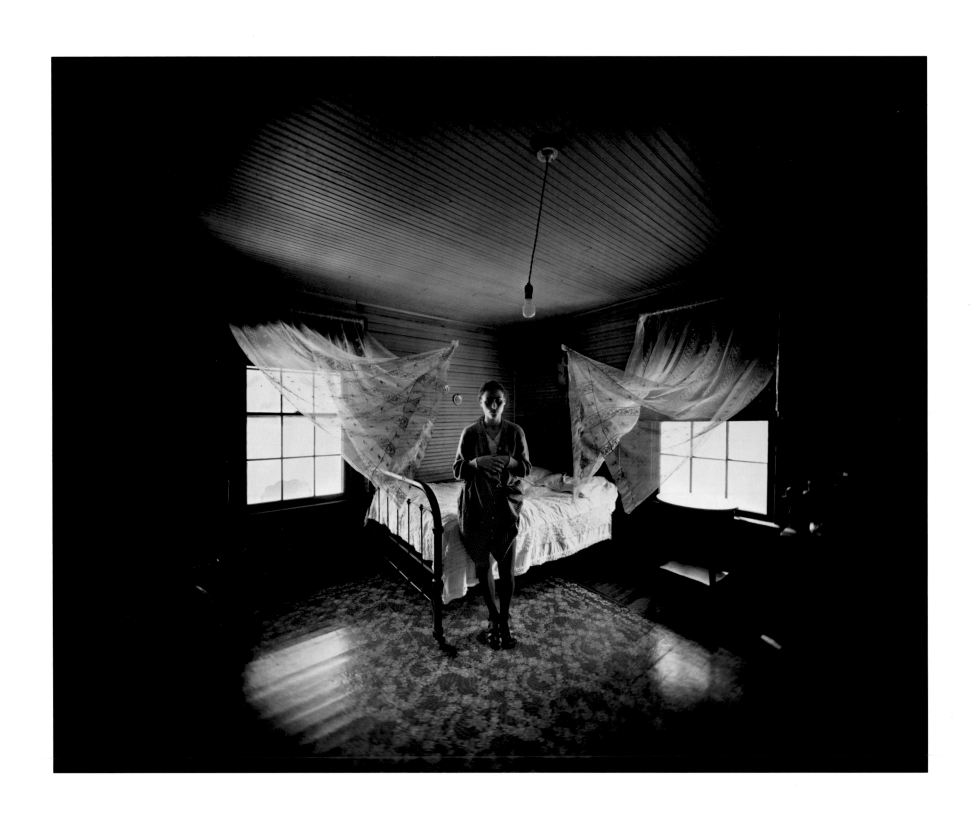

Edith, Danville, Virginia, 1970

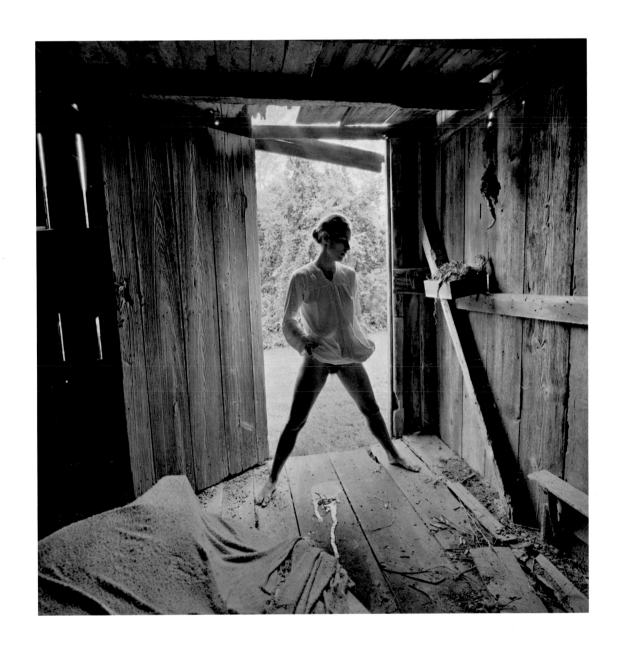

Edith, Danville, Virginia, 1971

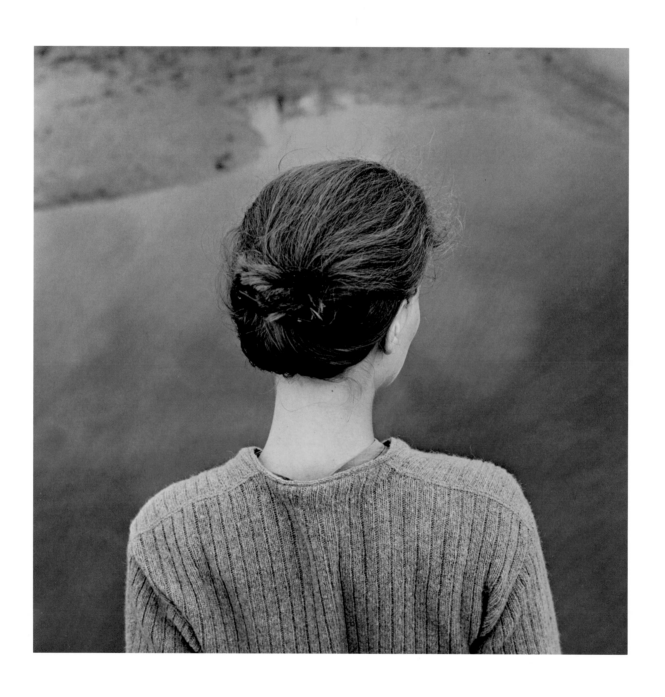

Edith, Chincoteague, Virginia, 1967

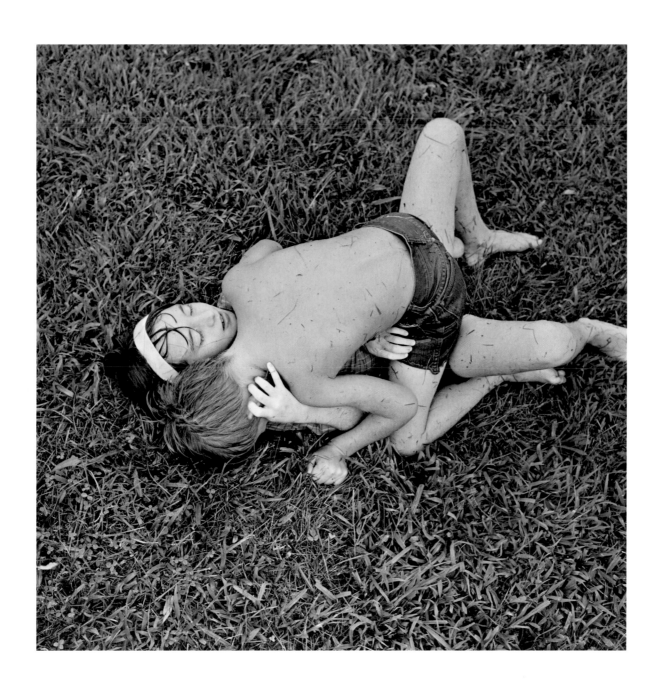

Nancy and Dwayne, Danville, Virginia, 1970

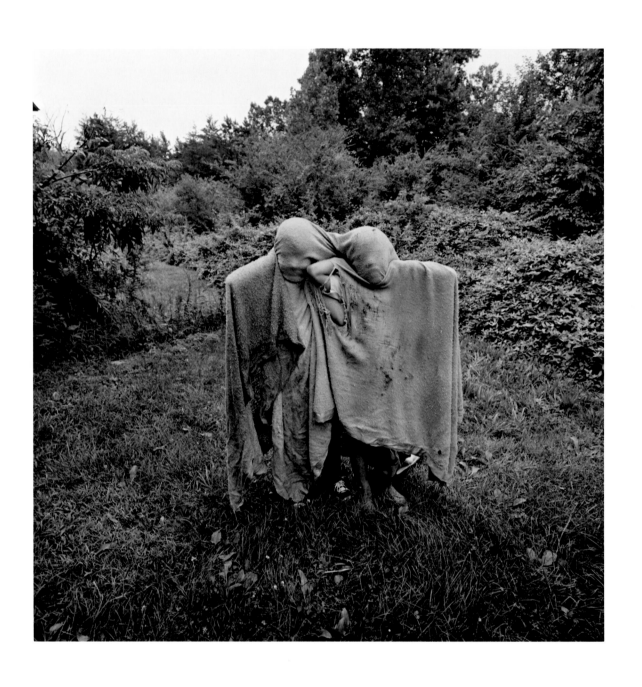

44 *Barry and Dwayne, Danville, Virginia, 1970*

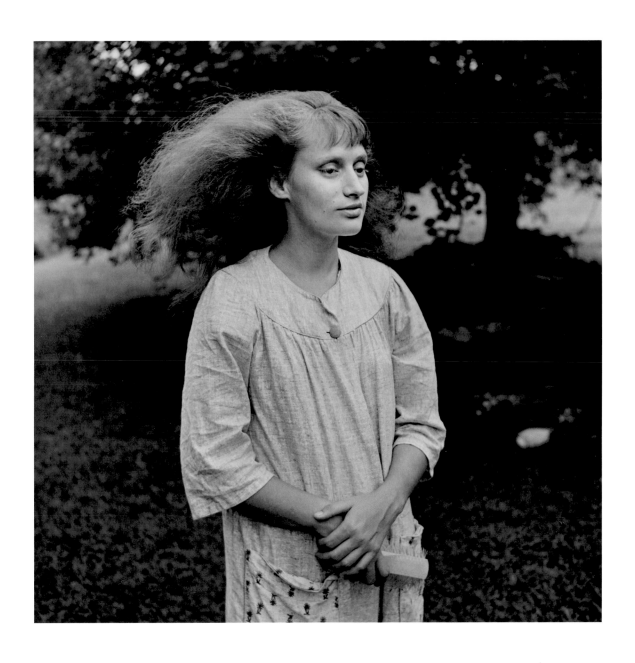

Ruth, Danville, Virginia, 1968

Every Time less than a pulsation of the artery
Is equal in its period & value to Six Thousand Years,

For in this Period the Poet's Work is Done, and all the
 Great
Events of Time start forth & are conciev'd in such a
 Period,
Within a Moment, a Pulsation of the Artery. . . .

For every Space larger than a red Globule of Man's
 blood
Is visionary, and is created by the Hammer of Los:
And every Space smaller than a Globule of Man's blood
 opens
Into Eternity of which this vegetable Earth is but a
 shadow.

WILLIAM BLAKE
From "Milton"

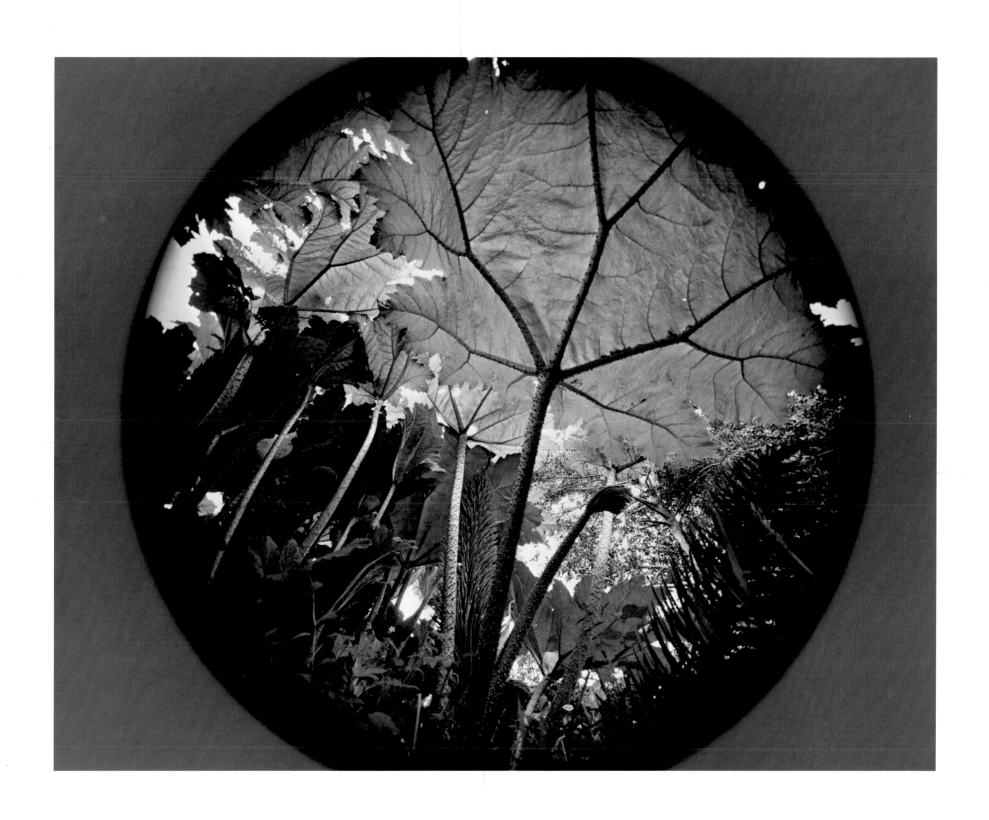

Ireland, 1972

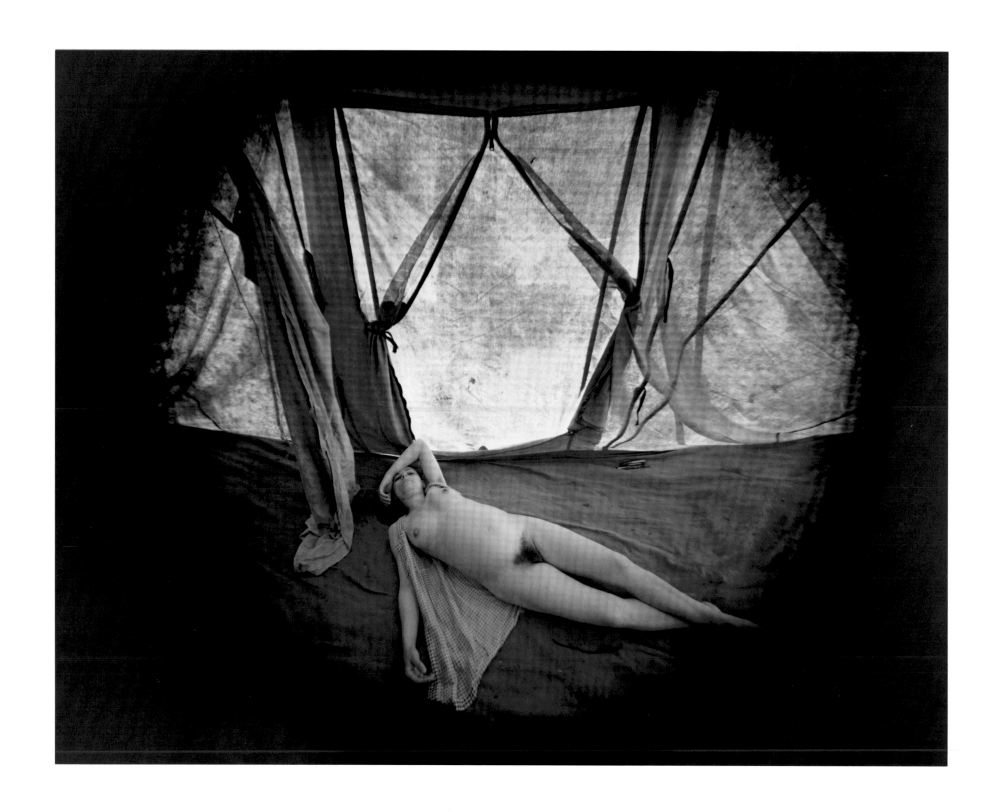

Edith, Newtown, Pennsylvania, 1974

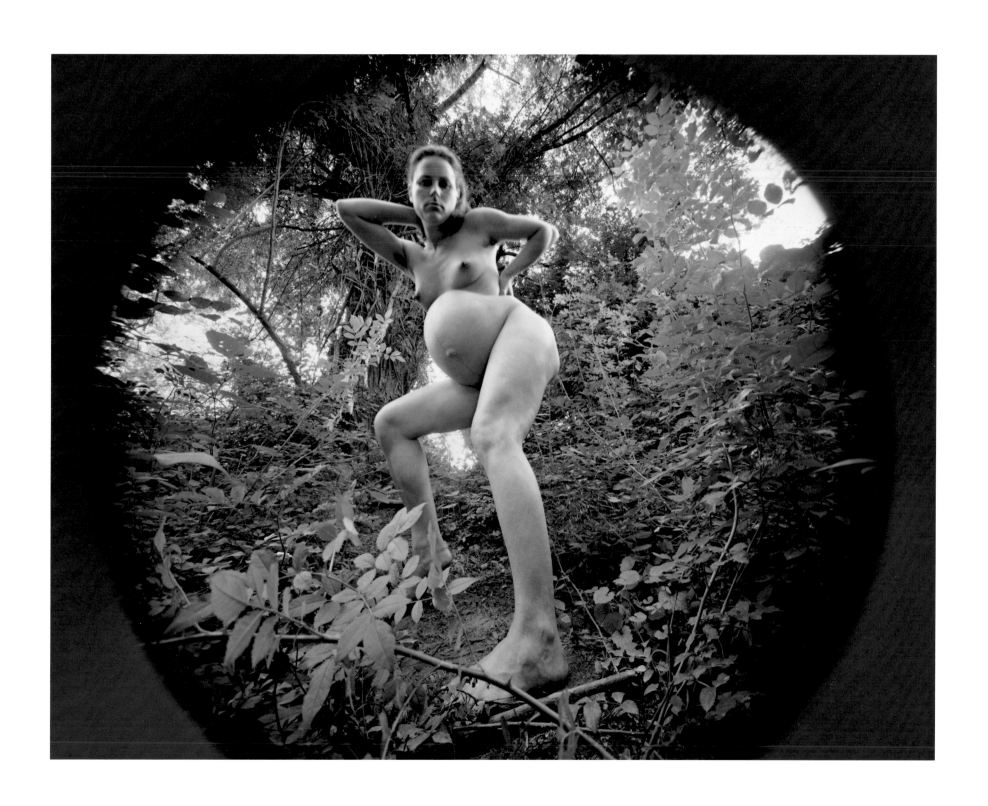

Edith, Newtown, Pennsylvania, 1974

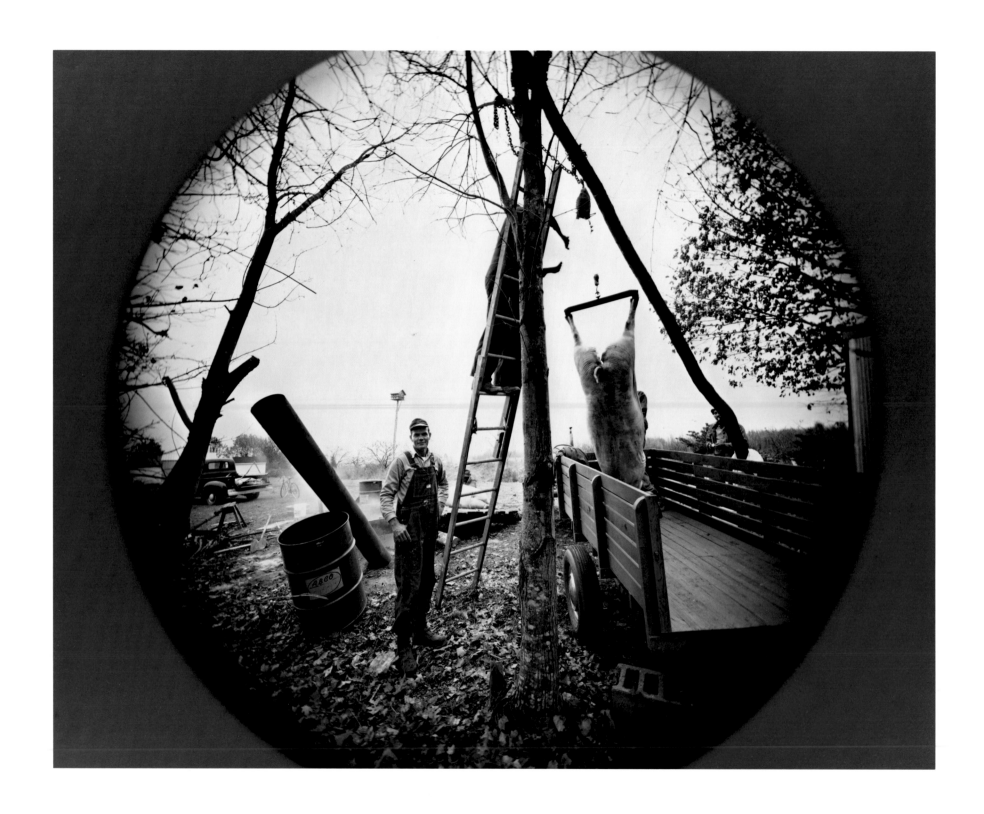

Hog Butchering Near Danville, Virginia, 1975

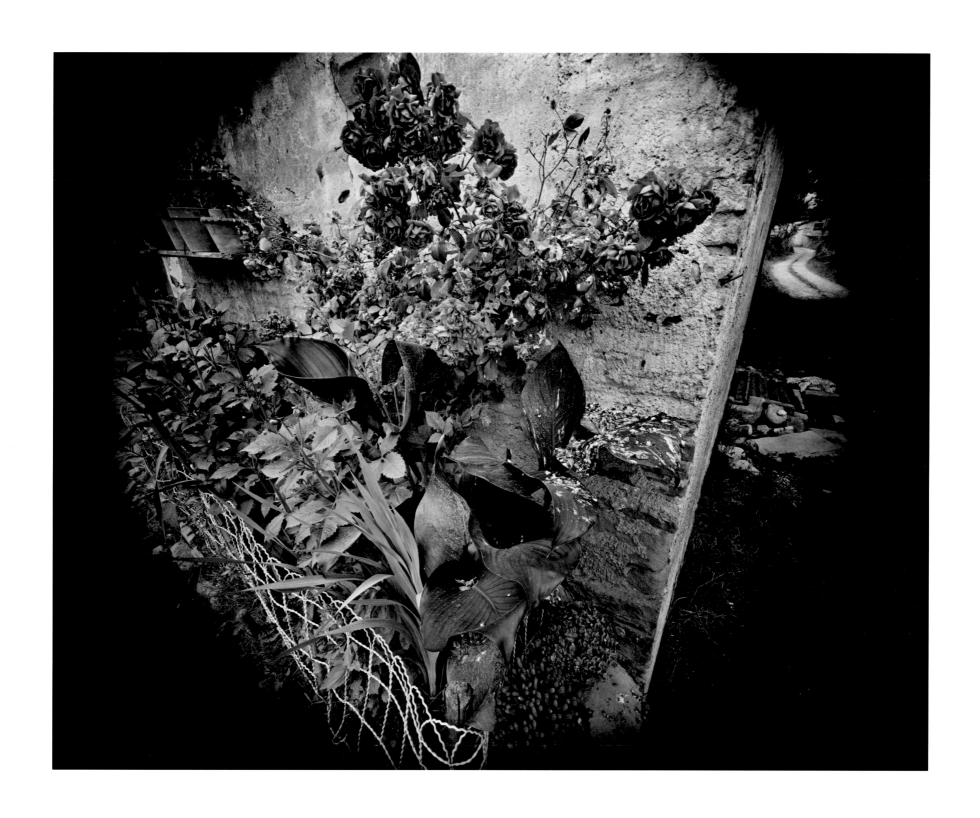

Scarperia, Italy, 1973

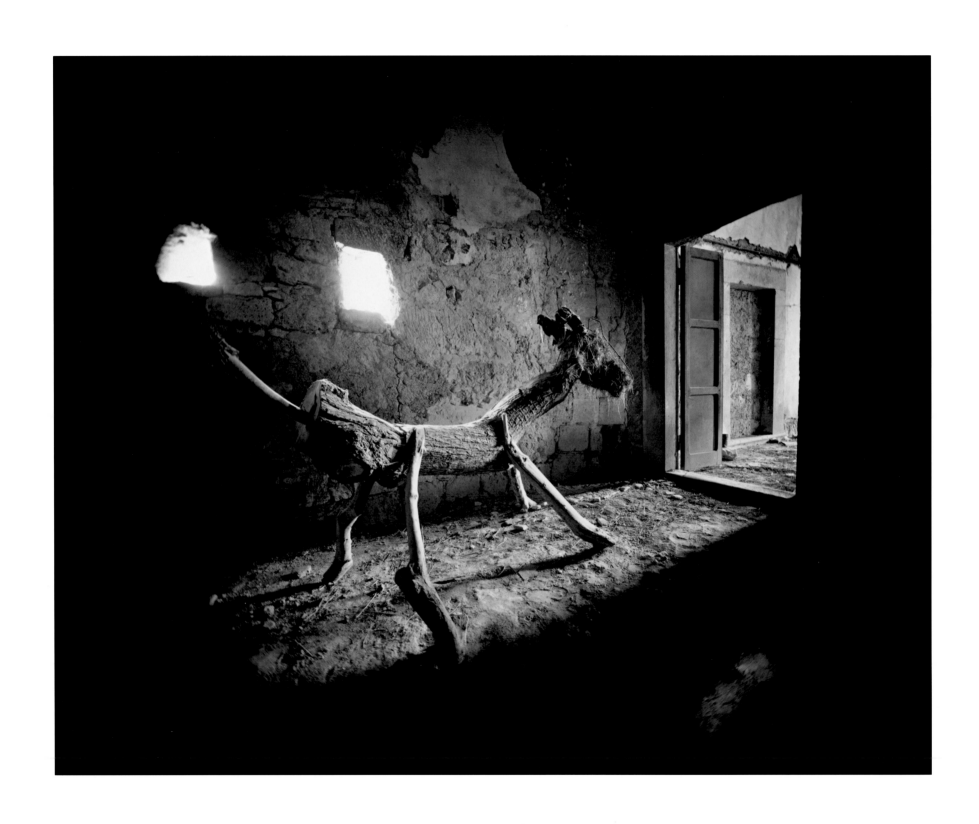

Civita di Bagnoregio, Italy, 1973

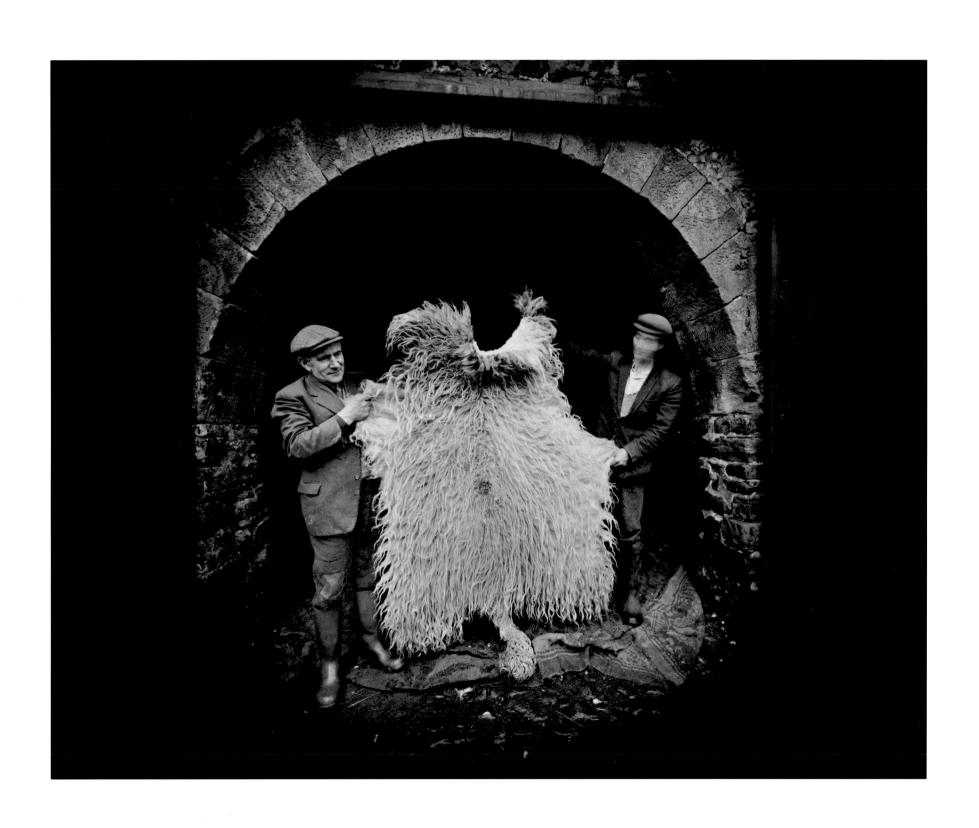

Sheep Fleece, Yorkshire, England, 1972

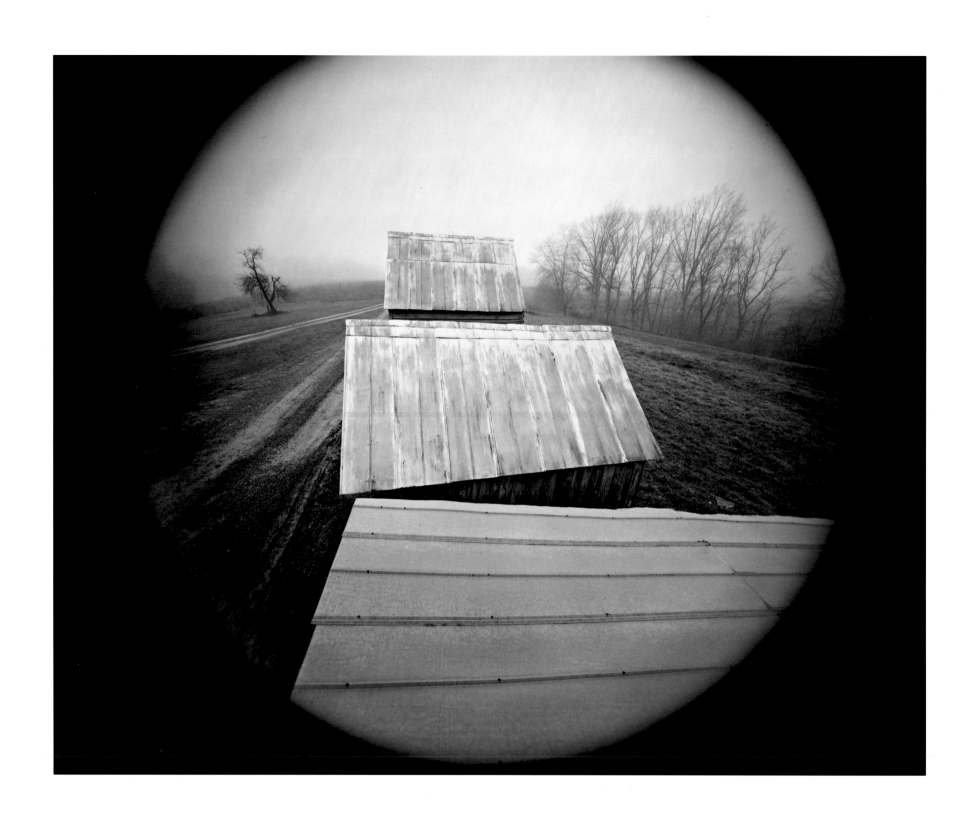

Buckingham County, Virginia, 1973

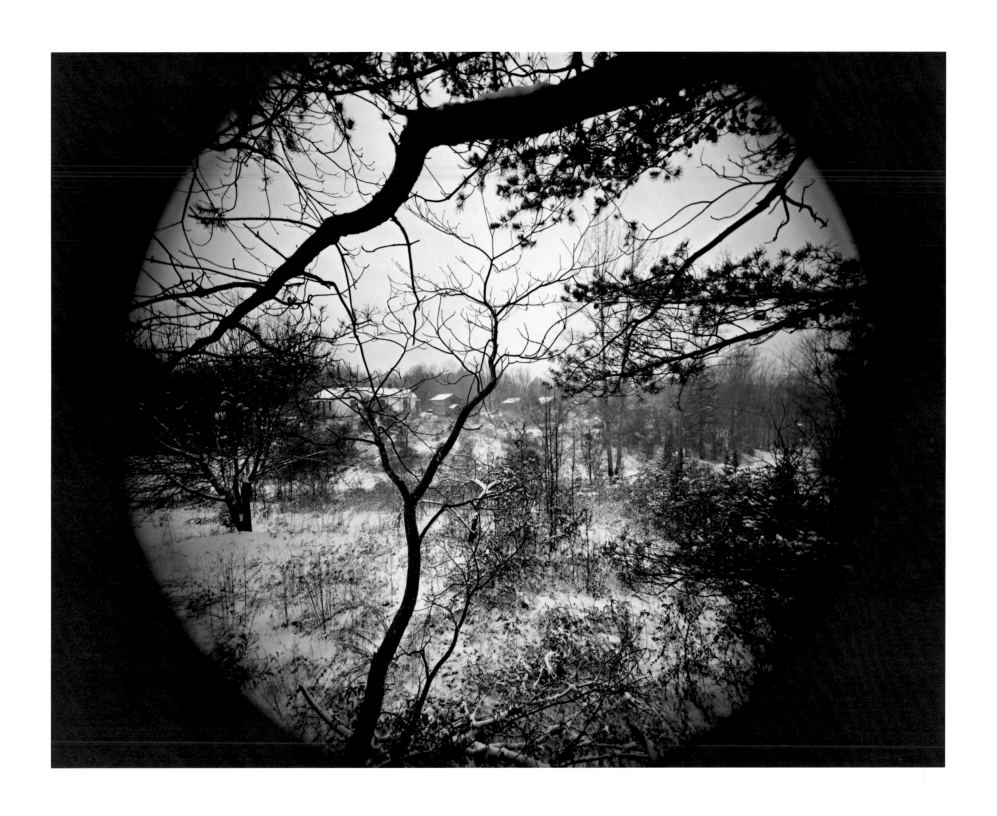

View of Rennie Booher's House, Danville, Virginia, 1973

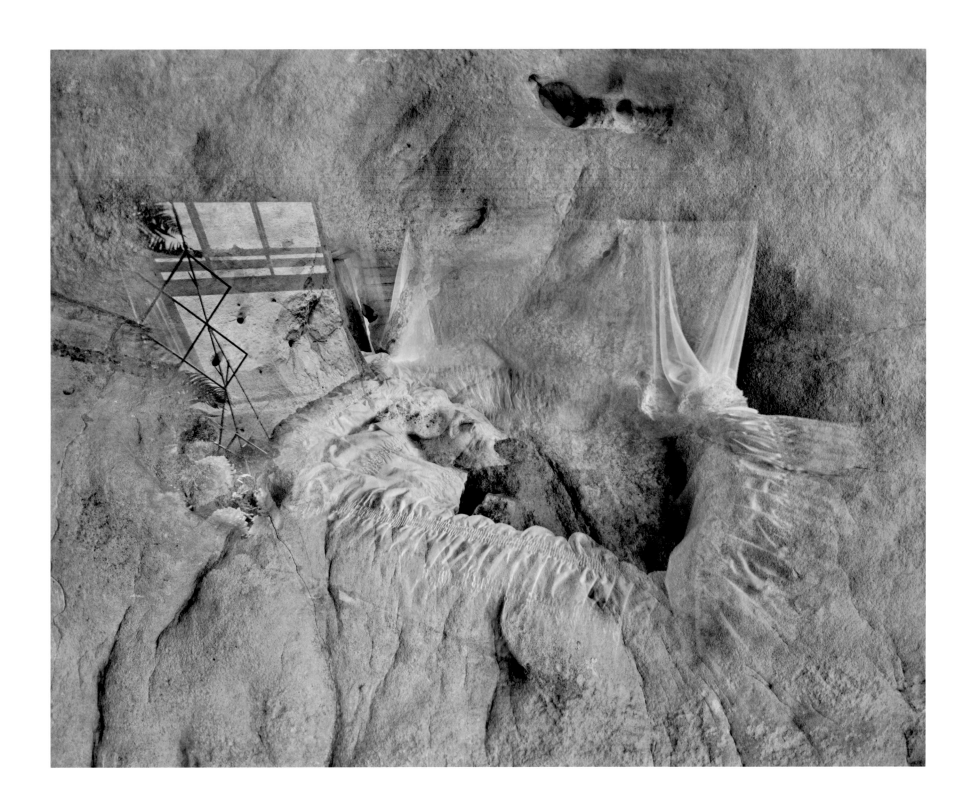

Avebury Stone and Rennie Booher, England and Danville, Virginia, 1972

Oysters, 1979

Cloth and Screens, Danville, Virginia, 1973

Mud Wasp Nests, Halifax County, Virginia, 1973

Artful Genealogies, 1976

Geography Pages, 1974

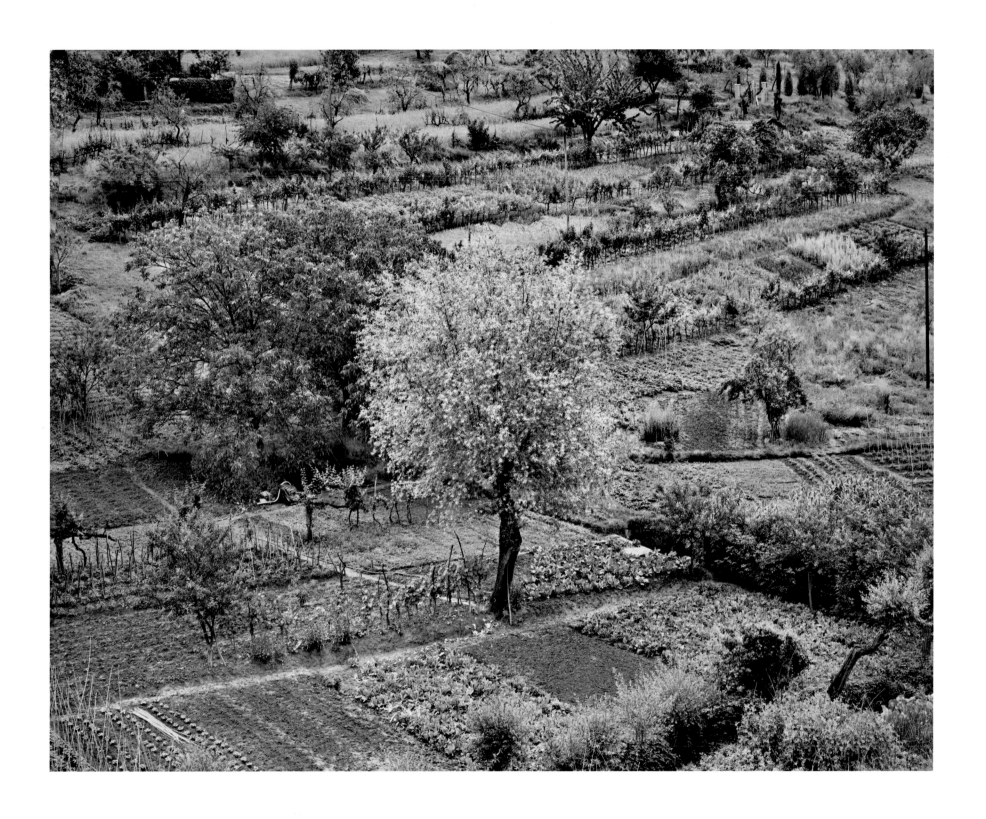

The Hint That Is a Garden: Siena, Italy, 1975. DEDICATED TO FREDERICK SOMMER

During the fall of 1979 Frederick Sommer led a series of seminars as visiting senior fellow at Princeton University. From the beginning I felt an intimate connection with those conversations. The notations below come directly from meetings with Sommer. A few of the phrases I had heard him use before, but all of them were entered into my notebook spontaneously, to preserve them as ideas with special meaning and value. Not only did I want to remember and share these amazingly direct thoughts, but they were ideas that my feelings could already verify from personal experience.

<div align="right">EMMET GOWIN</div>

Order is the sorting out of our feelings. § Time and quality of attention span lead to verification and credibility. § Another image can be made from the same parts. § Sensitivity enters the world through the way we treat things. § Watching someone else's troubles allows us to relax. § Why shouldn't the family run the risk of not knowing what you are going to do, since you do not know what you are going to do? § Honor father and mother and leave home. § Nourishment is to live things that are unsayable, that cannot be formulated. § You need conviction to understand. To learn you only need to be present. § Be more concerned with quality of acts than quality of art. § The business of art is nothing, while the business of life is everything. § There is no chance of touching the profound. § Before God our books will never balance. (Kierkegaard) § The important thing is quality of attention span, and to use it for acceptance rather than negation. § Imagination is the spirited appreciation of reality. § The more often we photograph the same thing the less freely we do it. § Every time you do something really worthwhile, you need time to absorb it—to recover from the shock. § Someone may say he is painting the image of a house, while in fact it may be an image of the tragedy within the house. § The burdens of a painting are the needs within which it was painted. § Sometimes we need to be bystanders, and to be bystanders is to give consent to what we do not yet understand or practice. § Things that apparently have nothing in common may have a better chance of fitting together. § The quality of workmanship reveals the motives. § A straight line in the right place can bring you to tears. § Knowing what you are doing just increases the obligations. § A person in a hurry is like a key fitting only one thing. § Content does not indicate our sensitivity, but the way we treat content is reflected in the way we make an image. § We fit back into the world when we are free of our projects. It's what we do every day in the simplest way that counts.

<div align="right">FREDERICK SOMMER</div>

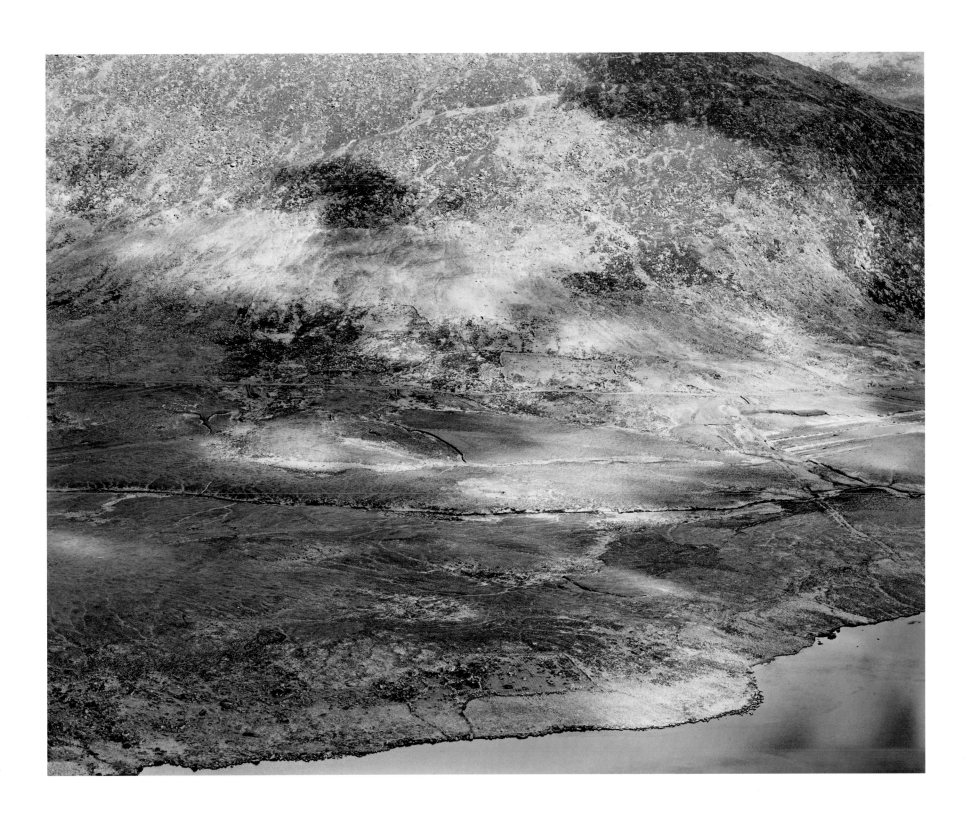

Connor Pass, Dingle Peninsula, County Kerry, Ireland, 1978

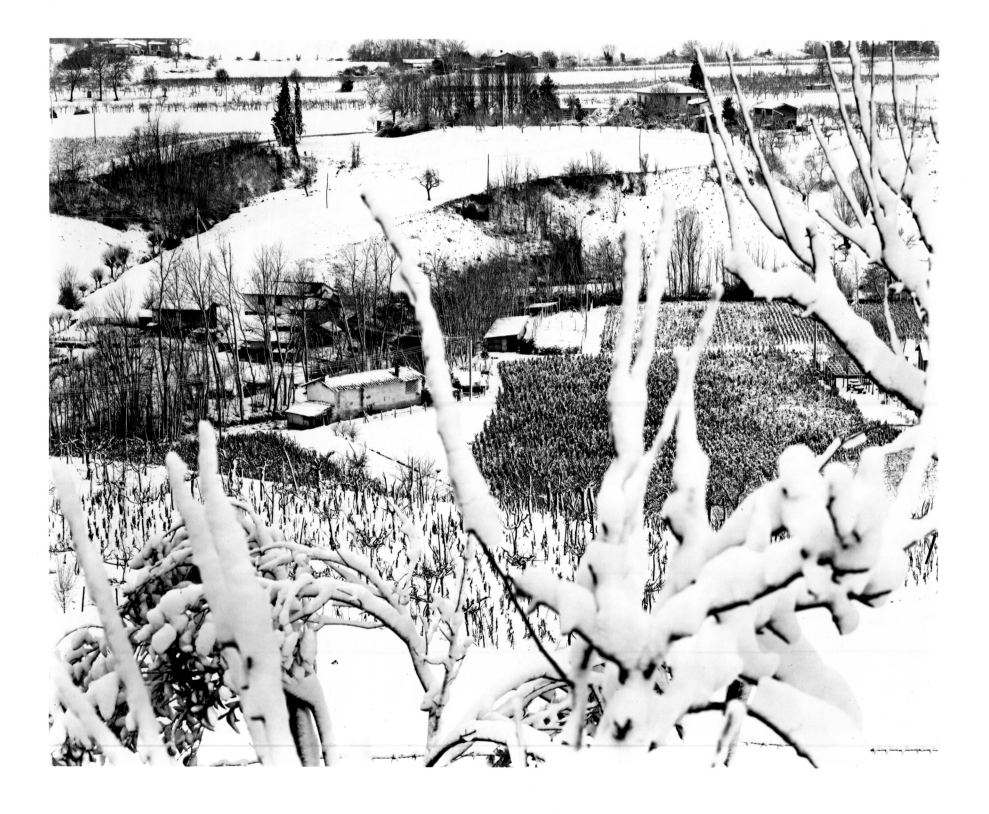

Scarperia, Italy, 1981

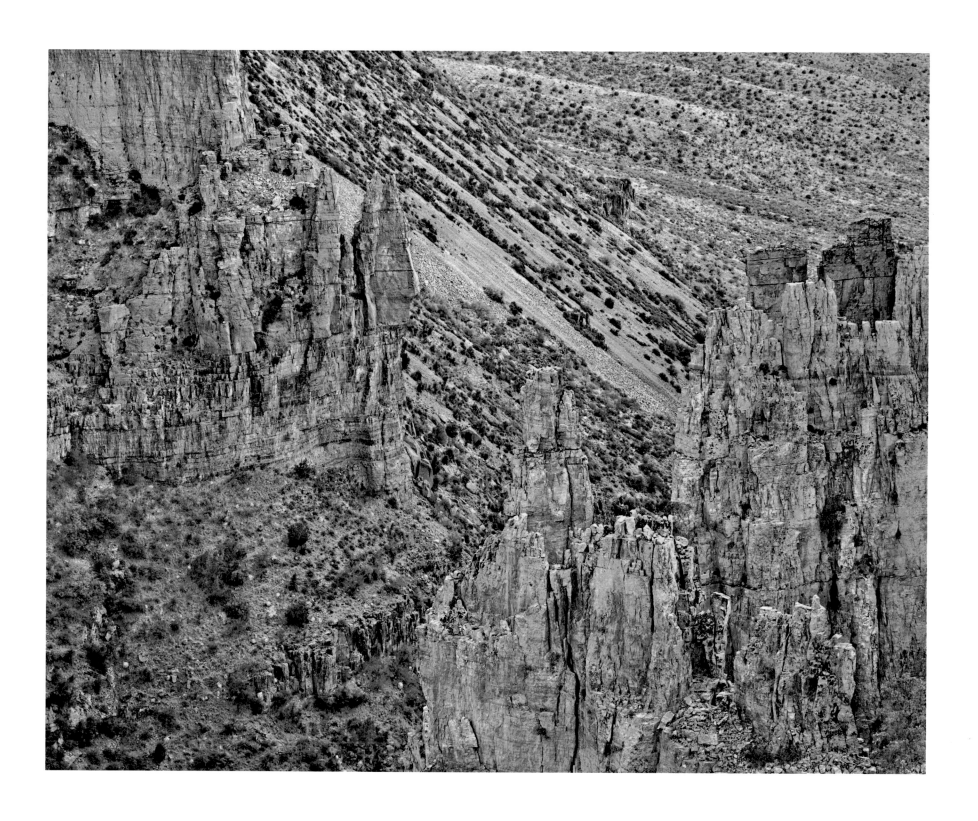

Canyon at Dick Landis's Home, Parker Creek, Arizona, 1981

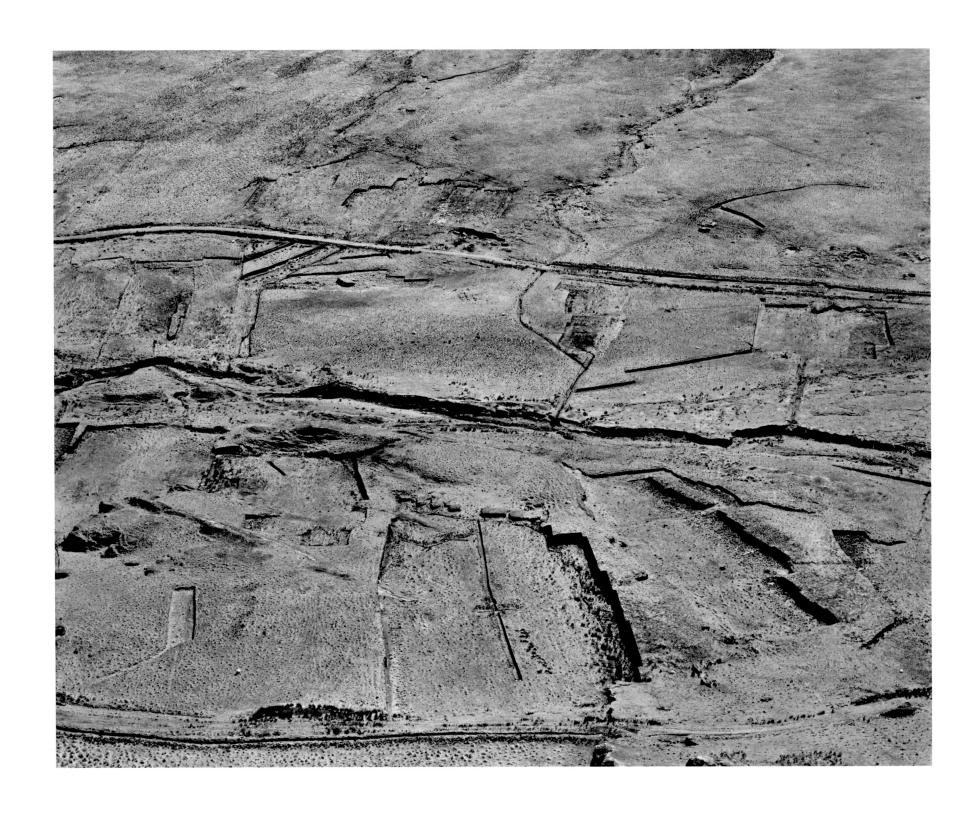

Peat Bog, Ireland, 1978

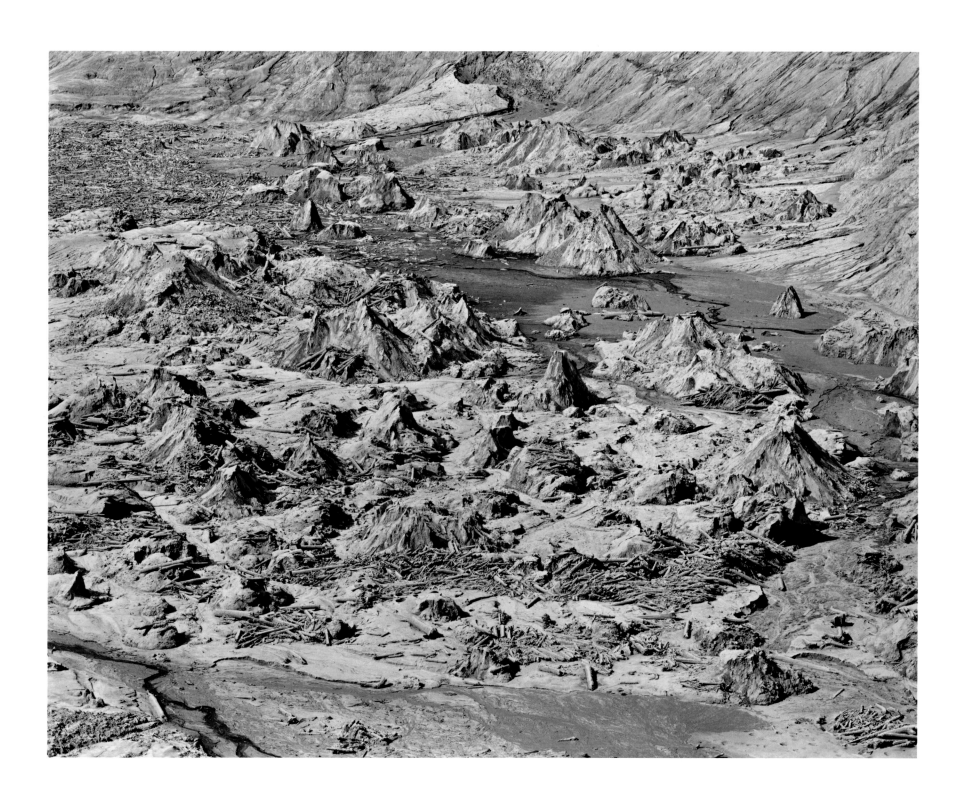

Bear Cove, Mount St. Helens, Washington, 1980

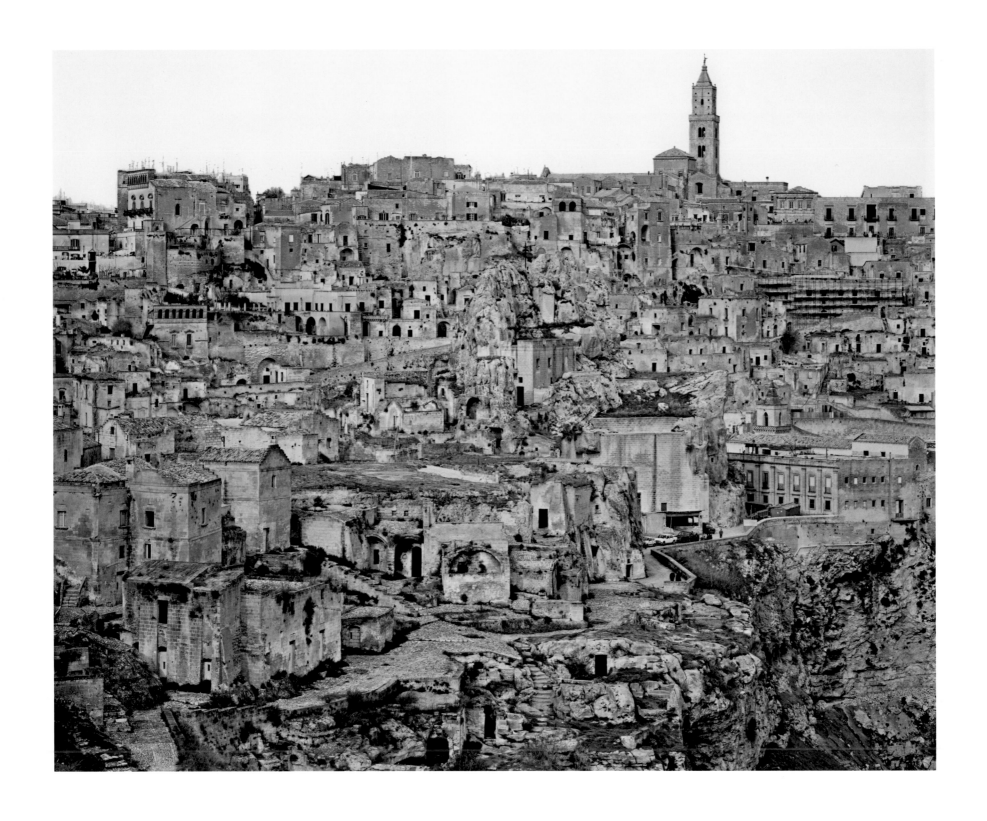

Matera, Italy, 1980

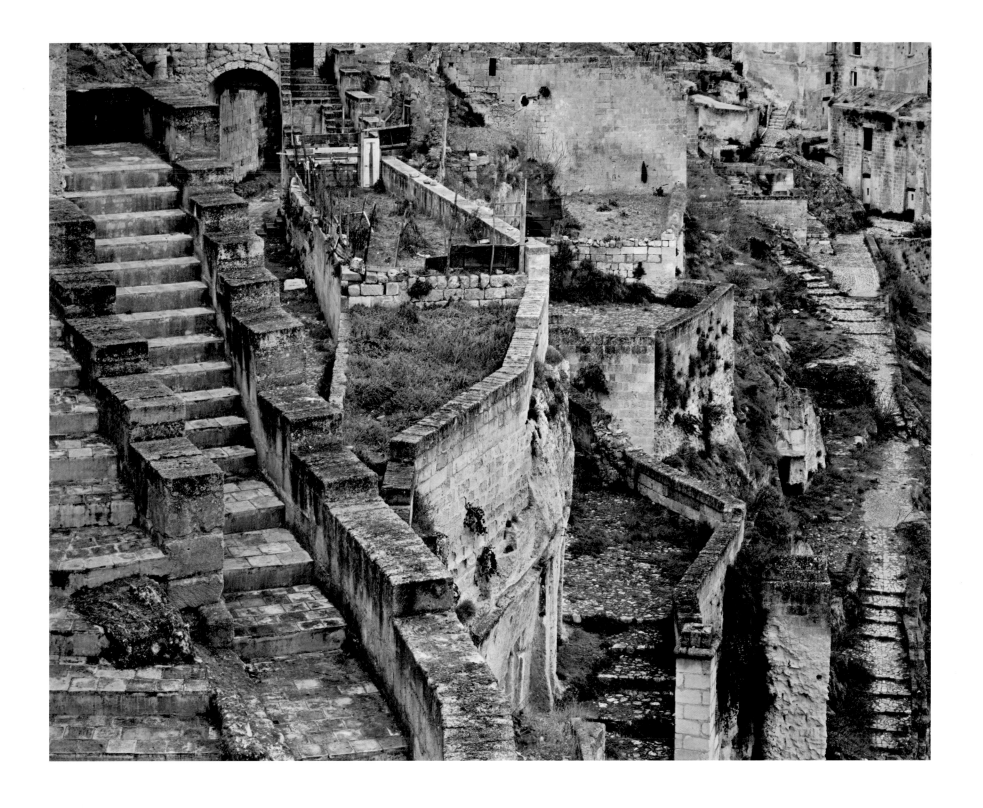

Matera, Italy, 1980

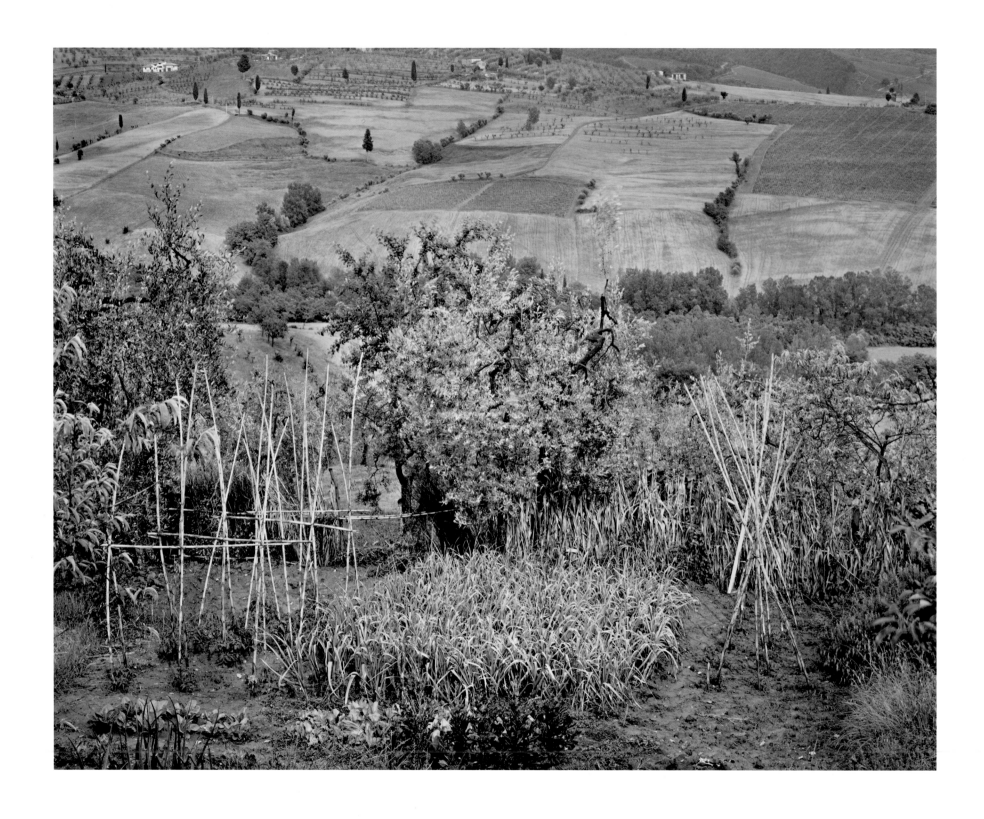

Poggibonsi, Italy, 1978

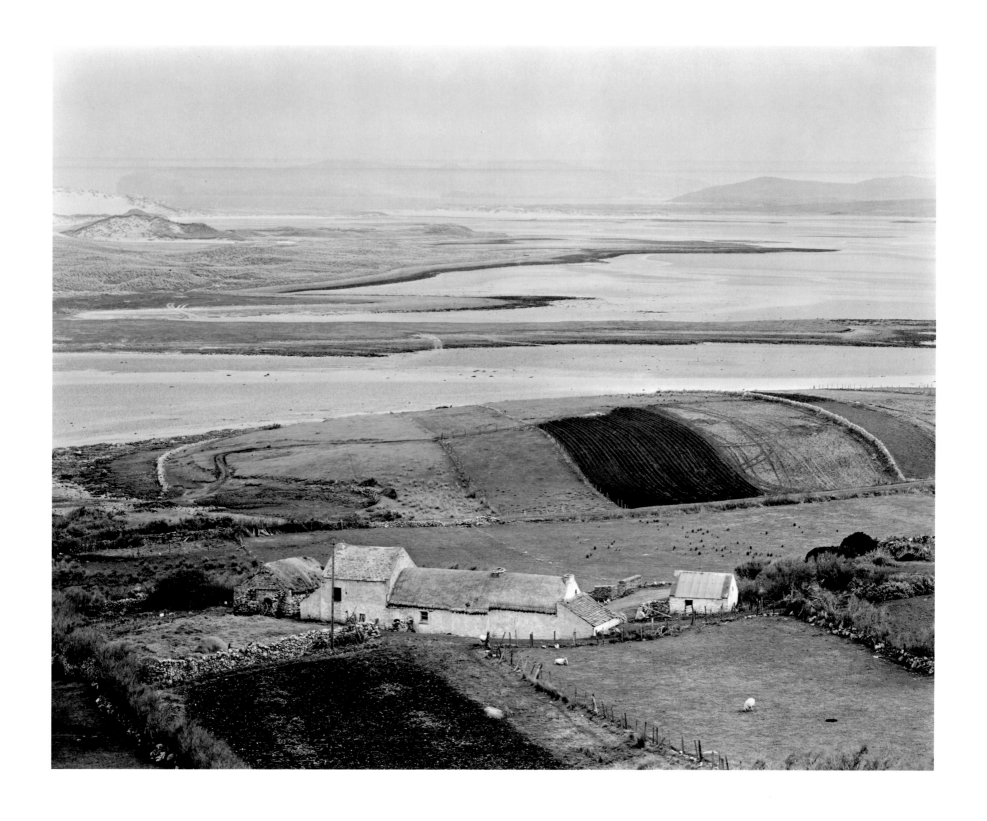

Ireland, 1978

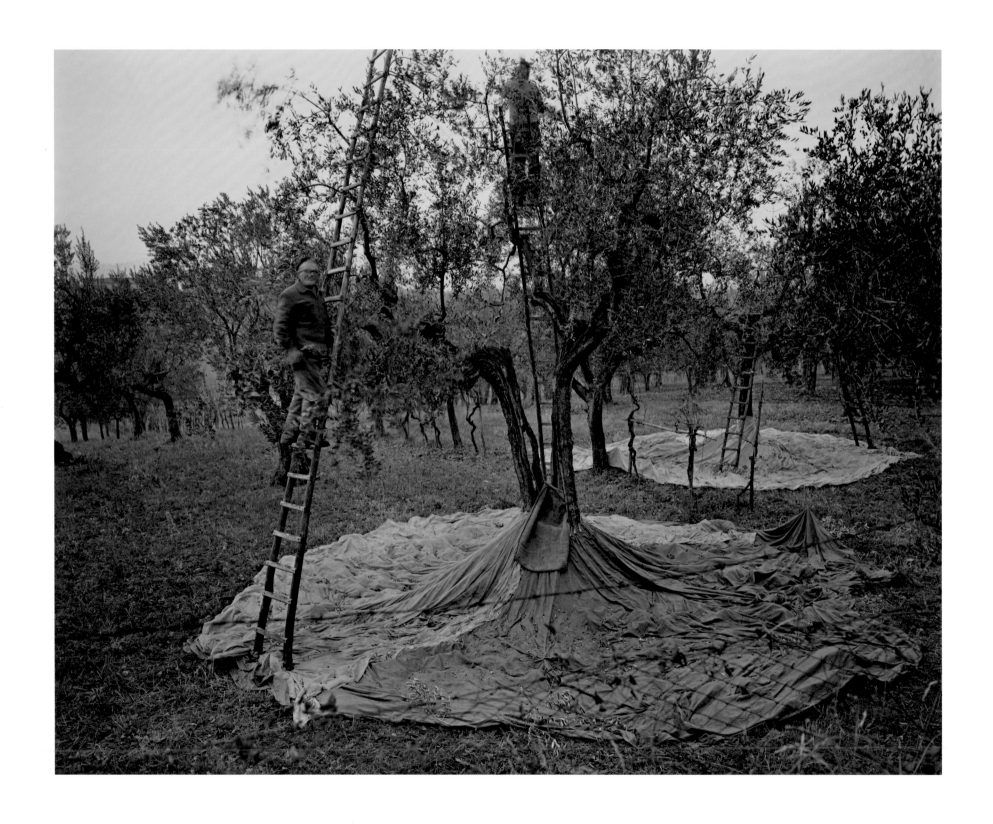

Bagno a Ripoli, Italy, 1980

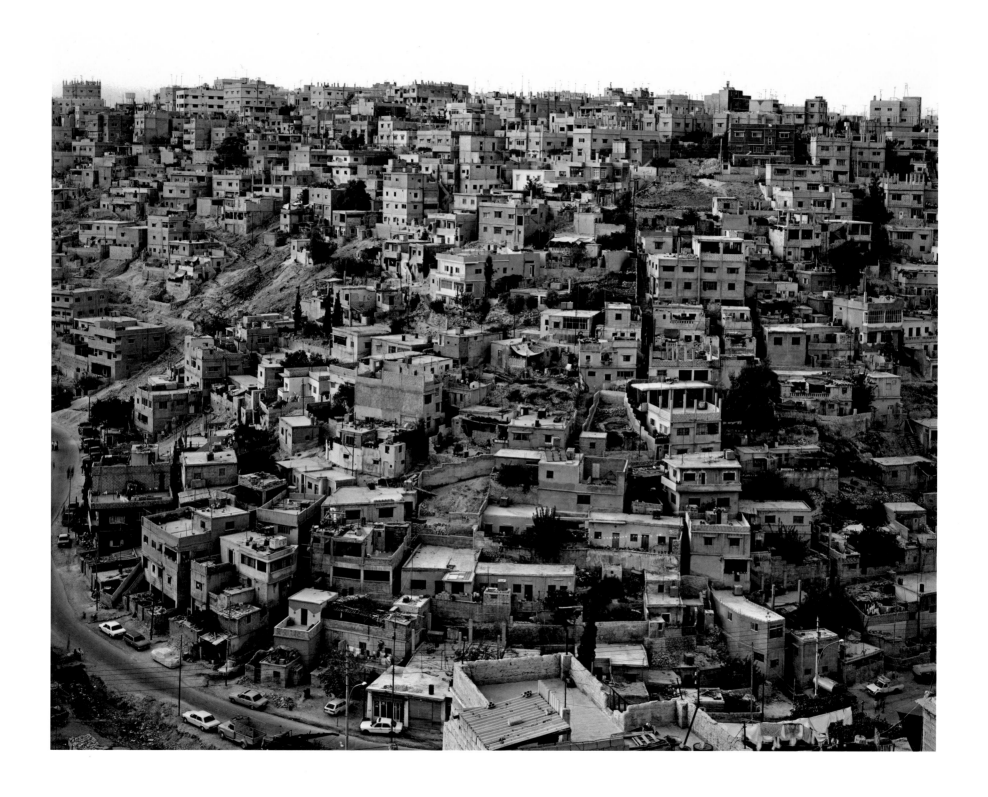

Amman, Jordan, 1982

CODA

Inseparable from the fire
 its light
 takes precedence over it.
Then follows
 what we have dreaded—
 but it can never
overcome what has gone before.
 In the huge gap
 between the flash
and the thunderstroke
 spring has come in
 or a deep snow fallen.
Call it old age.
 In that stretch
 we have lived to see
a colt kick up his heels.

Do not hasten
 laugh and play
in an eternity
 the heat will not overtake the light.
 That's sure.
That gelds the bomb,
 permitting
 that the mind contain it.
This is that interval,
 that sweetest interval,
 when love will blossom,
come early, come late
 and give itself to the lover.
Only the imagination is real!
 I have declared it
 time without end.

WILLIAM CARLOS WILLIAMS
From "Asphodel, That Greeny Flower"

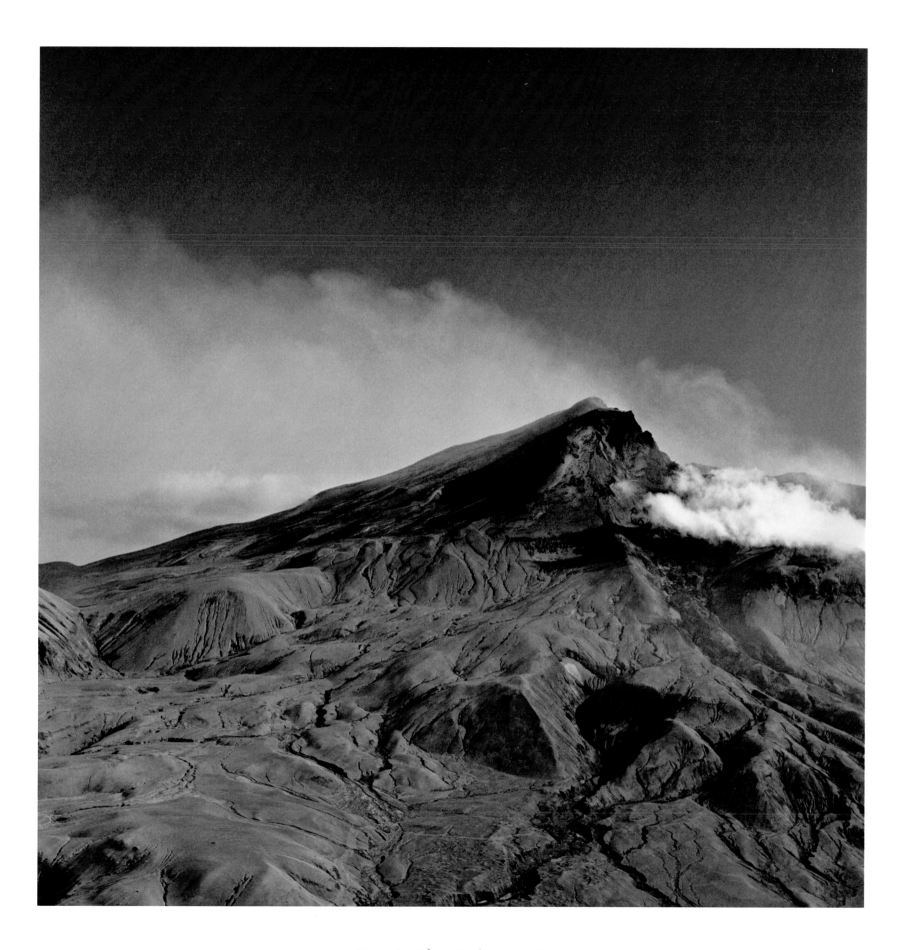

Mount St. Helens, Washington, 1984

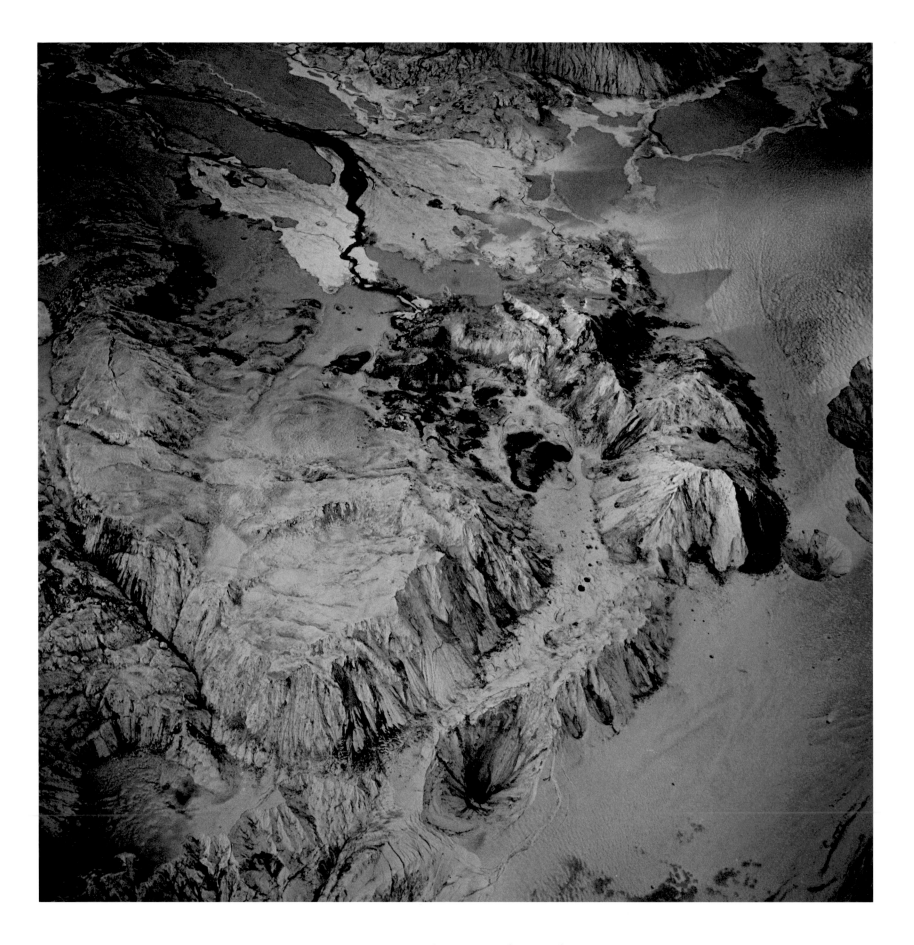

Toutle River Valley, Area of Mount St. Helens, Washington, 1980

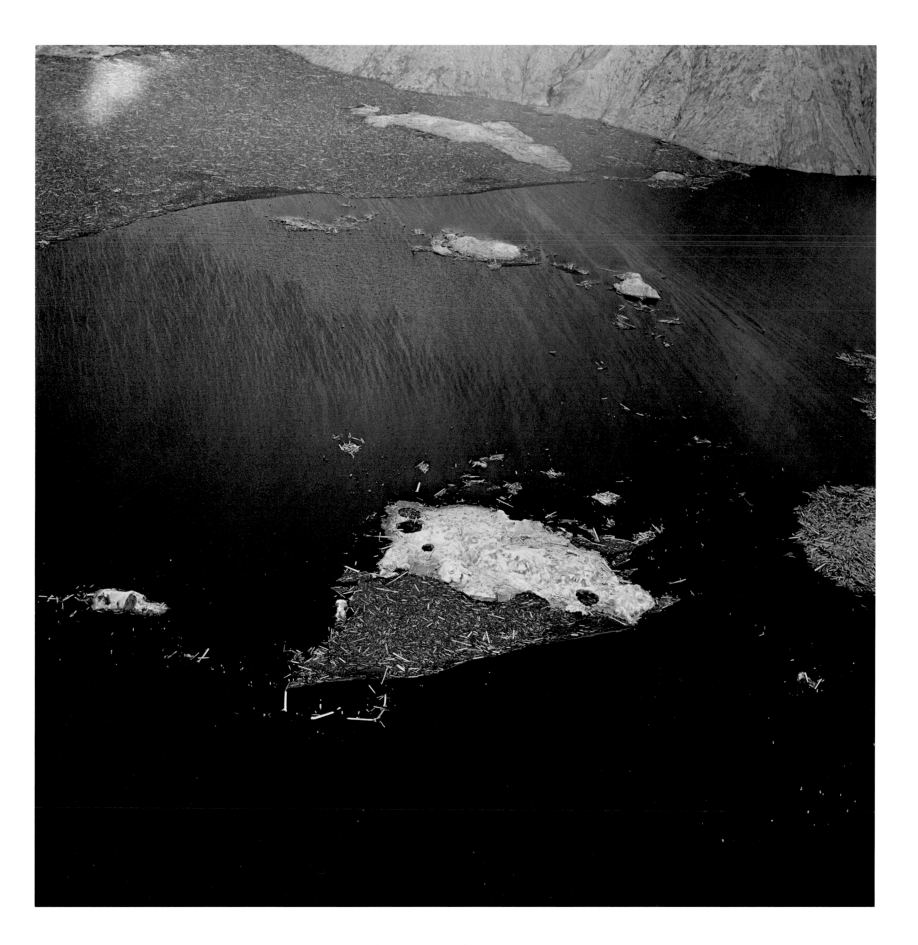

Spirit Lake, Mount St. Helens, Washington, 1980

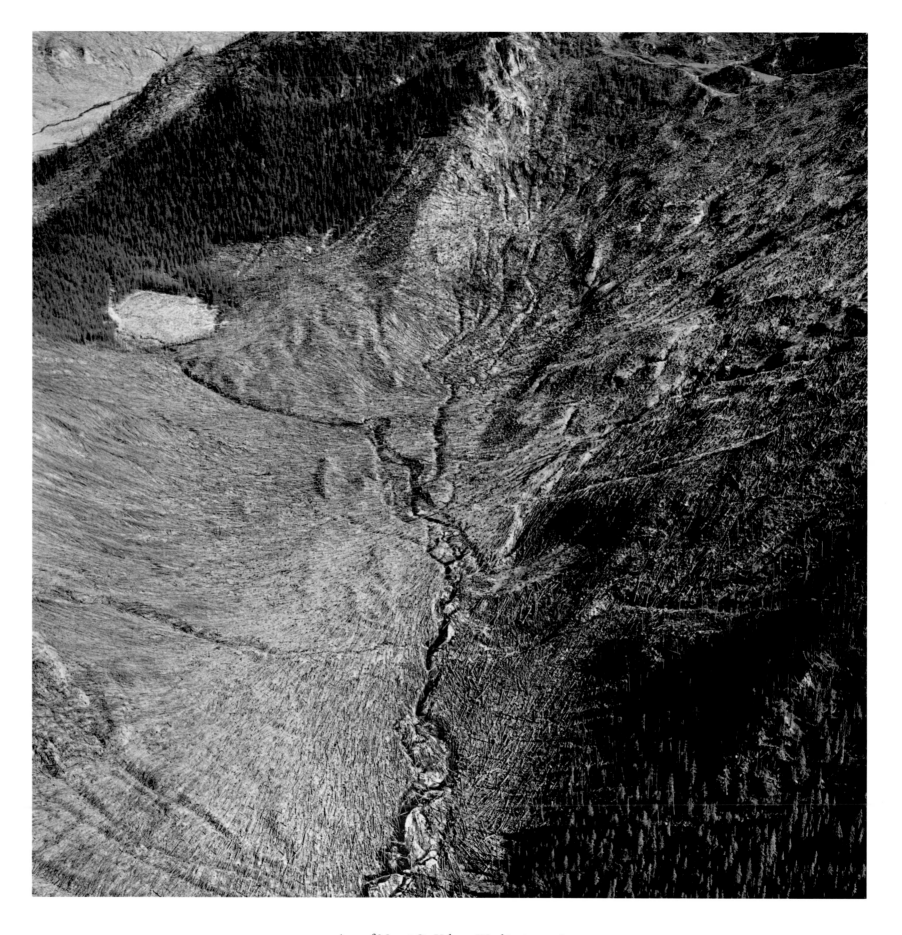

Area of Mount St. Helens, Washington, 1981

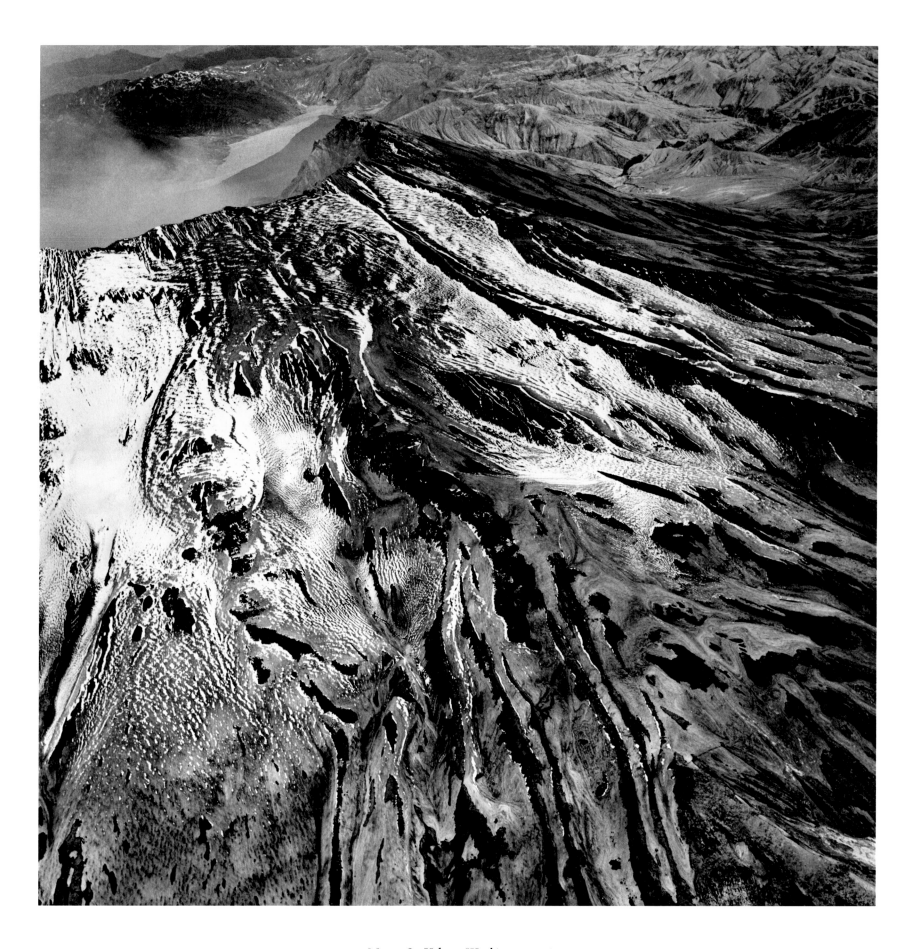

Mount St. Helens, Washington, 1983

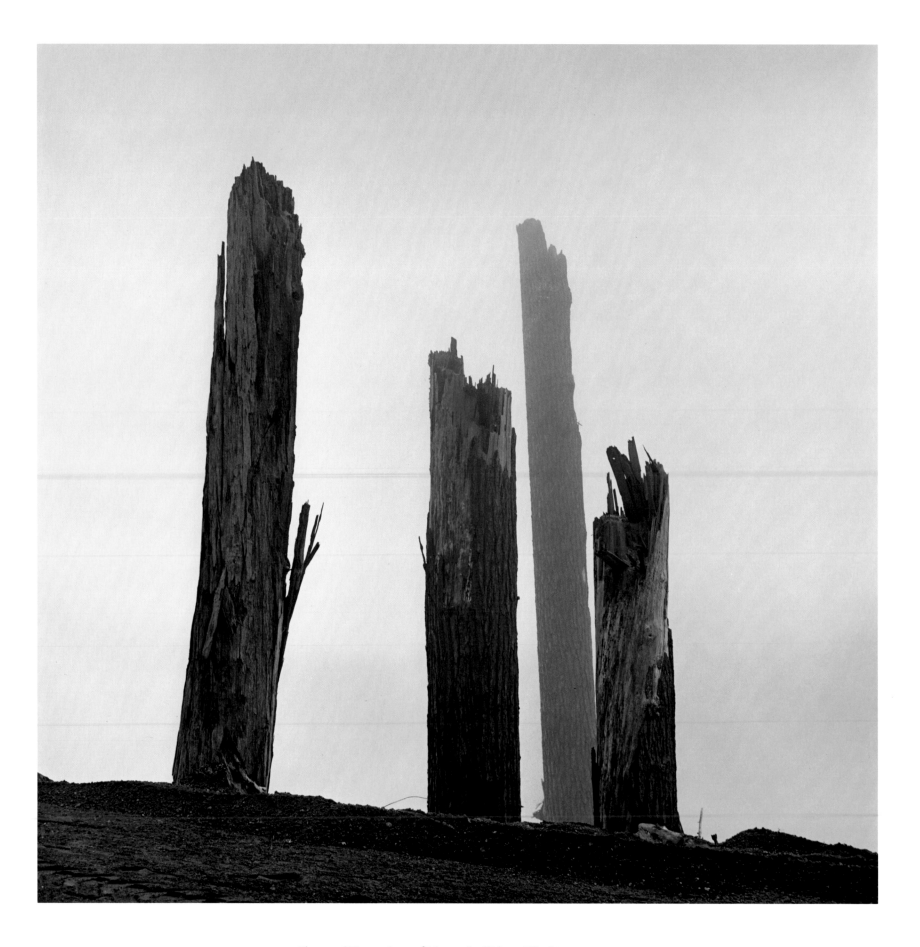

Shattered Trees, Area of Mount St. Helens, Washington, 1982

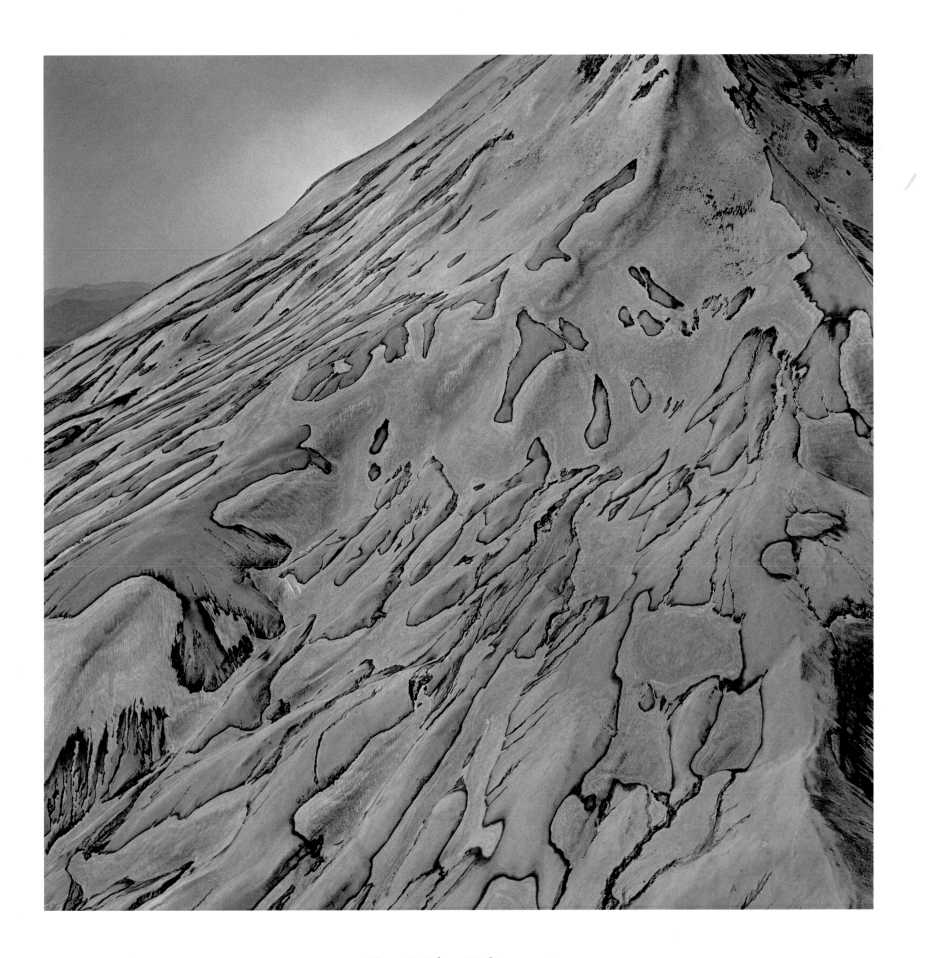

Mount St. Helens, Washington, 1982

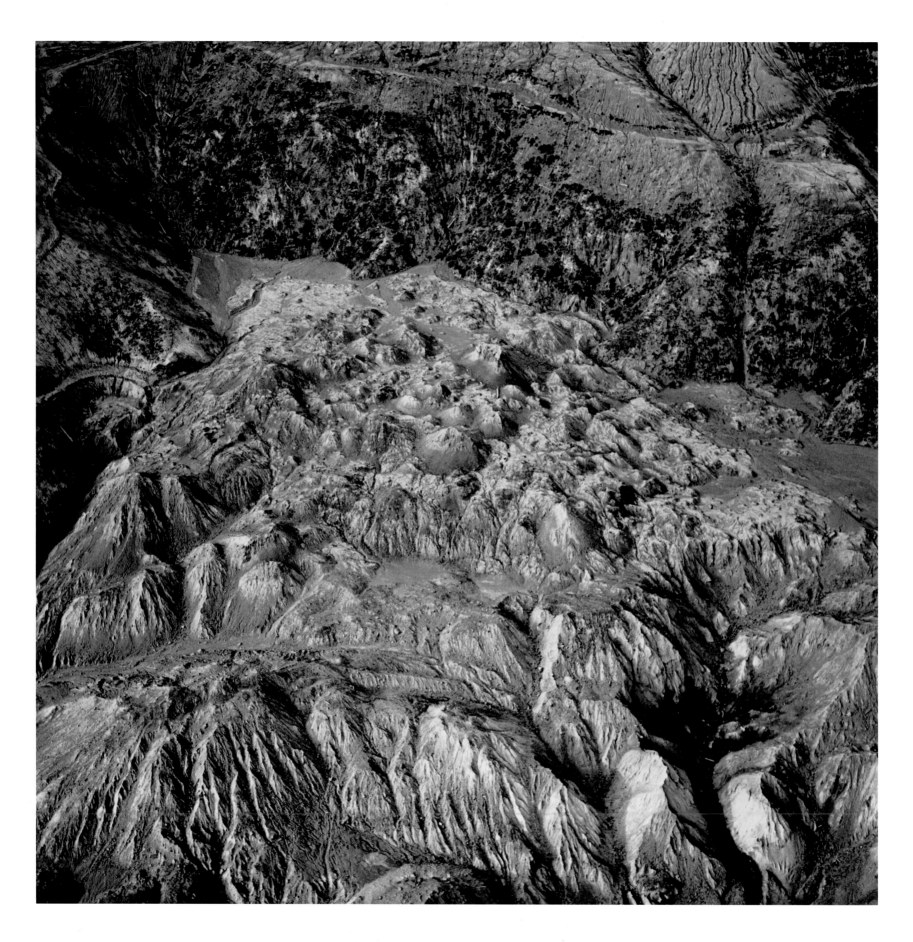

Debris, Toutle River Valley, Mount St. Helens, Washington, 1983

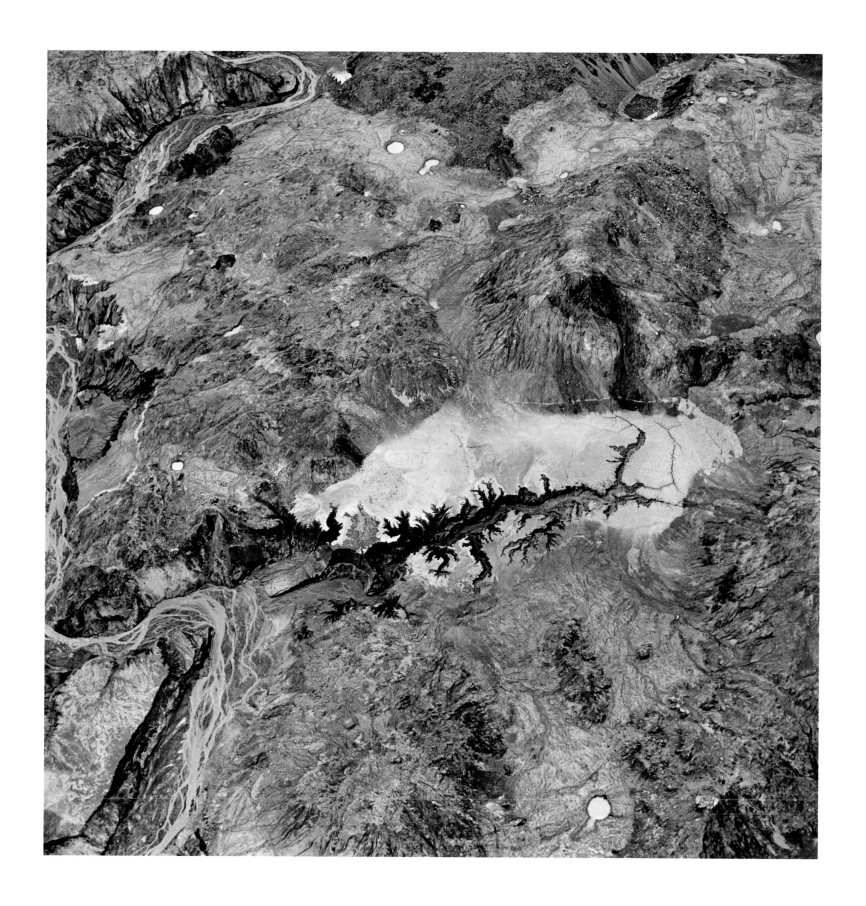

Toutle River Valley, Mount St. Helens, Washington, 1981

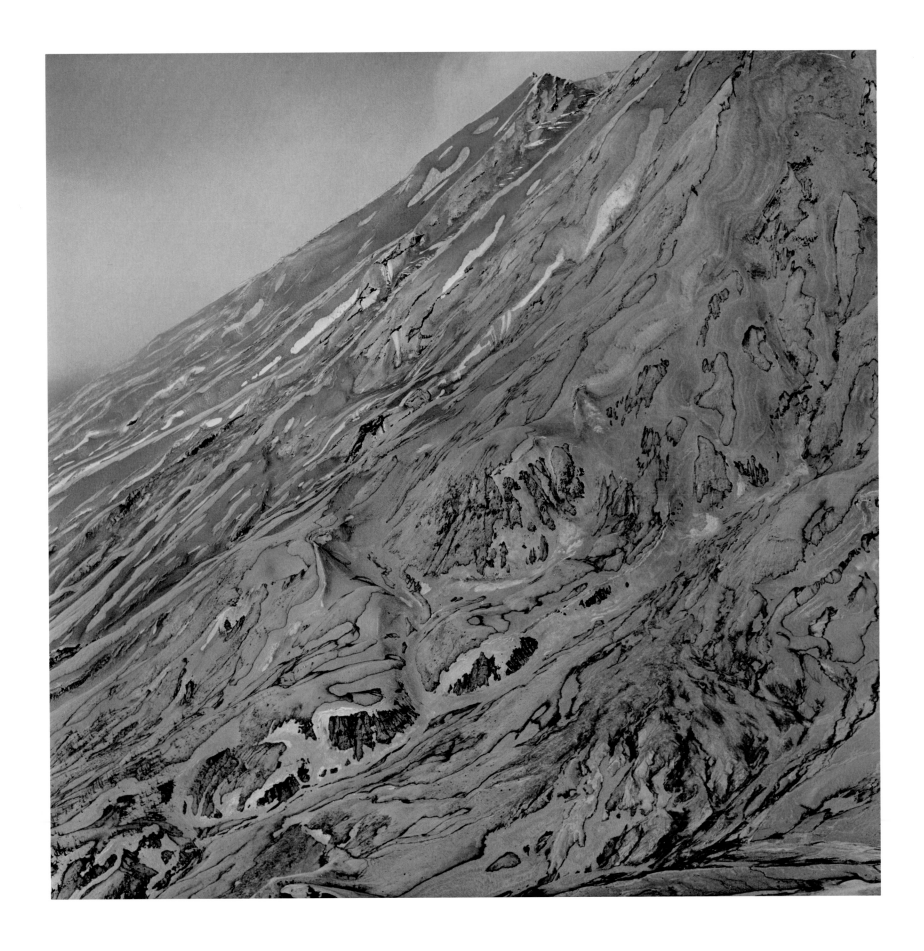

Mount St. Helens, Washington, 1982

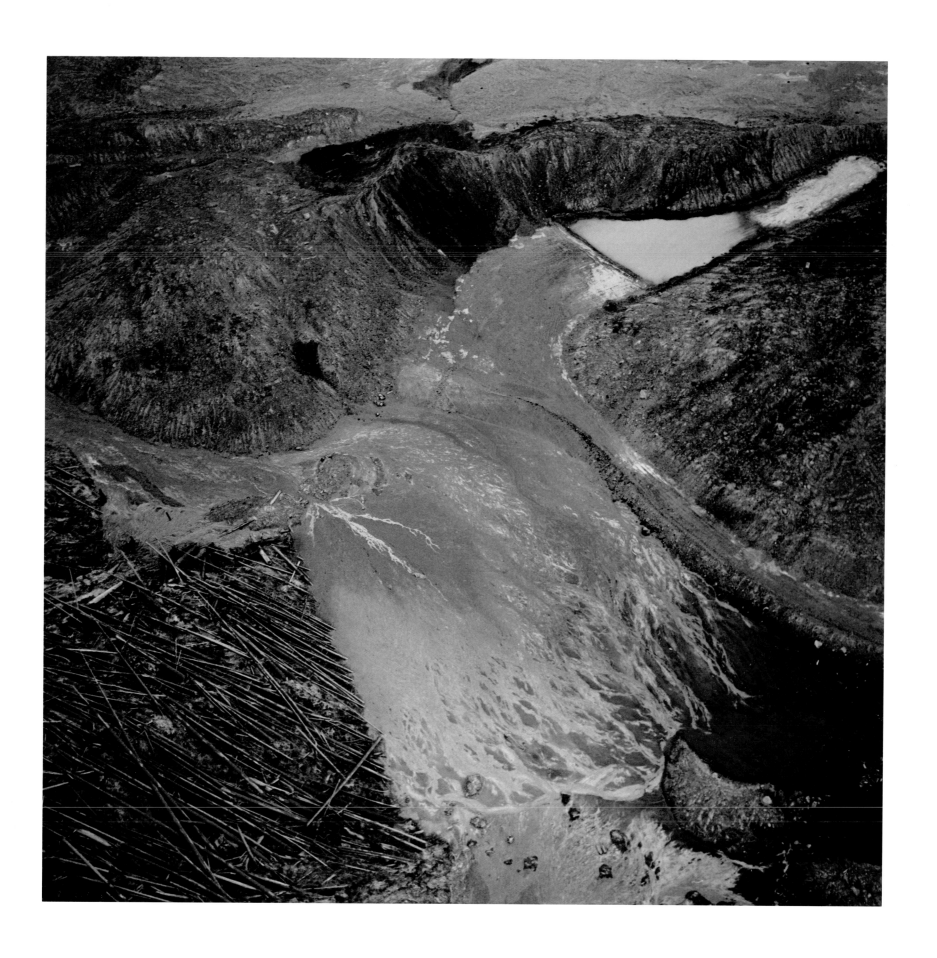

Toutle River Valley, Mount St. Helens, Washington, 1983

87

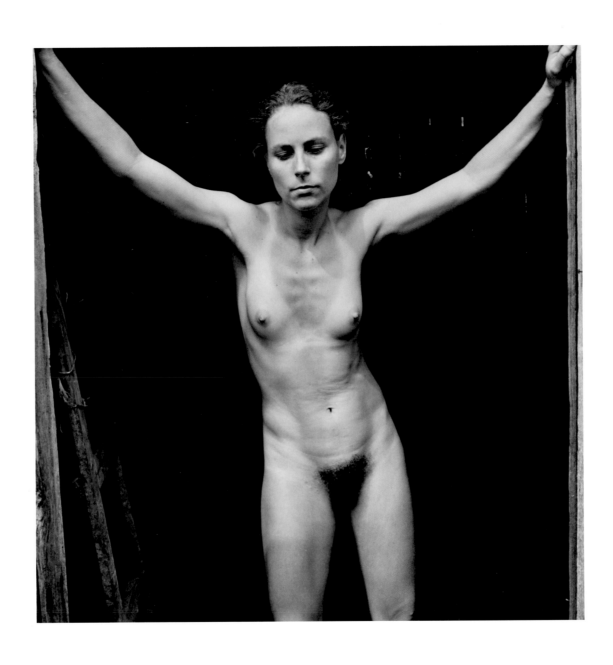

Edith, Danville, Virginia, 1973

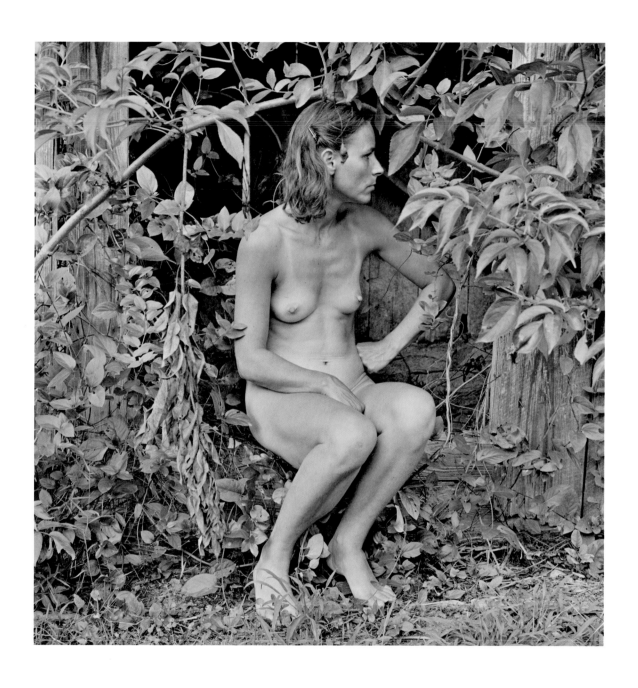

Edith, Danville, Virginia, 1980

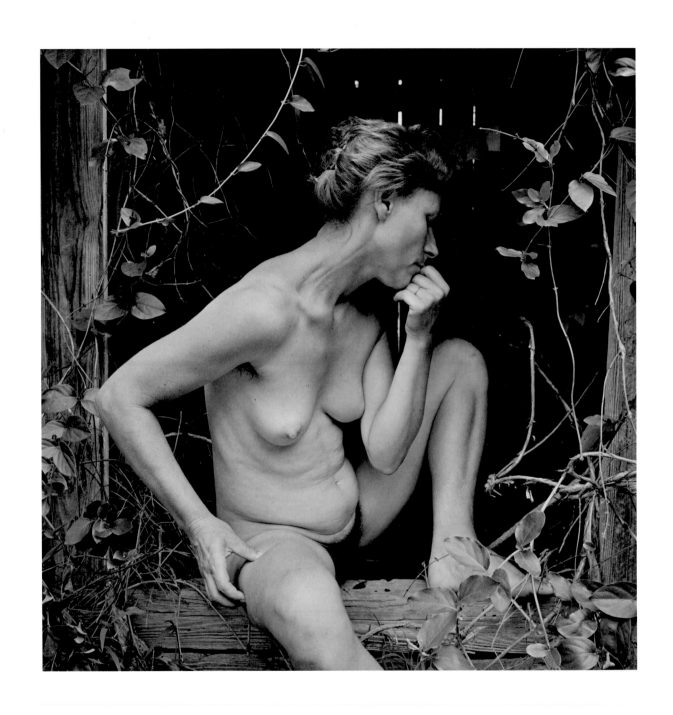

Edith, Danville, Virginia, 1983

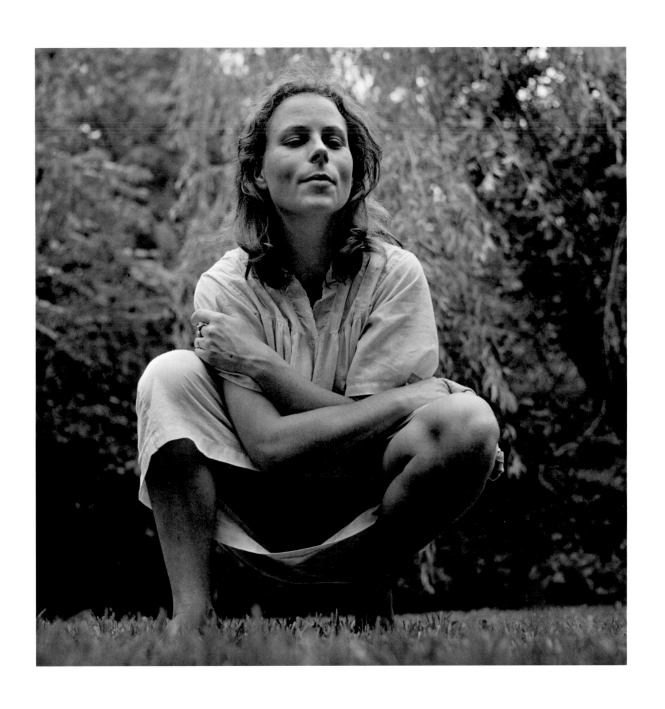

Edith, Danville, Virginia, 1978

There is a profound silence that whines in the ear, a breathless quiet, as if the light or something unheard was breathing. I hold my breath to make certain it's not me. It must be the earth itself breathing.

In the desert brilliance, light and the heat demand our attention, but it is the early morning and the evening that are the most holy of times. Evening is also the hour of mystery. Whole mountains turn amber, redden, then bloody, in the sobering light that begins the birth of night. In such a quiet envelope of air and light, there is an equilibrium not unlike forgiveness. Finally darkness opens itself, releasing an infinity of stars.

EMMET GOWIN

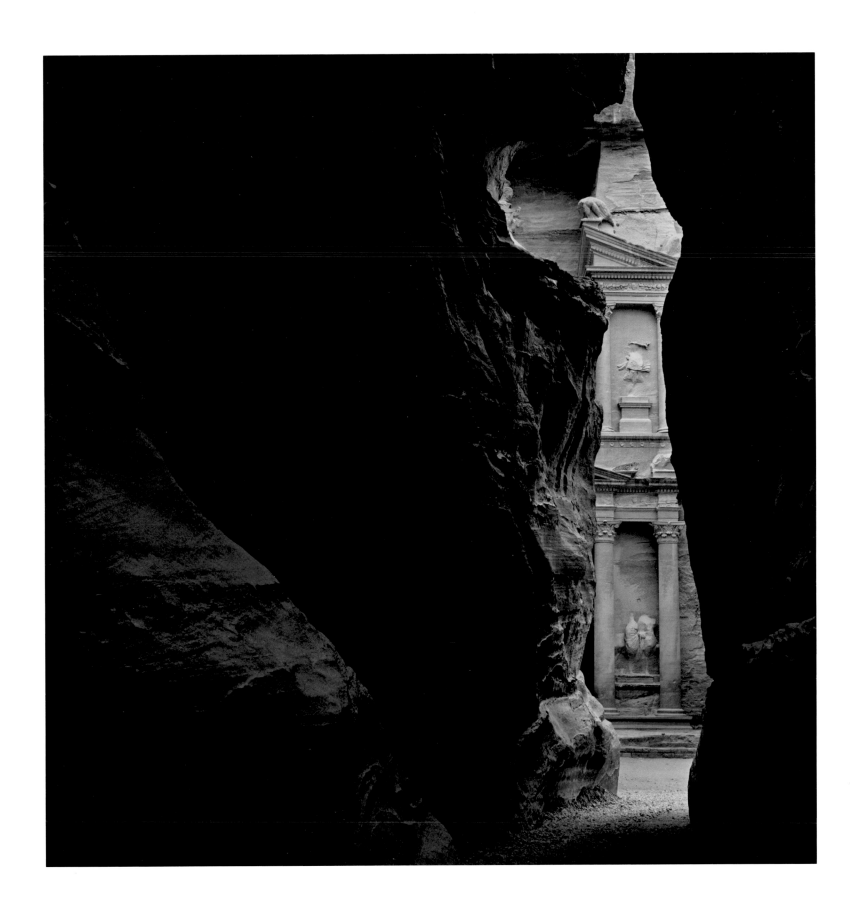

El Khazneh from the Siq, Petra, Jordan, 1985

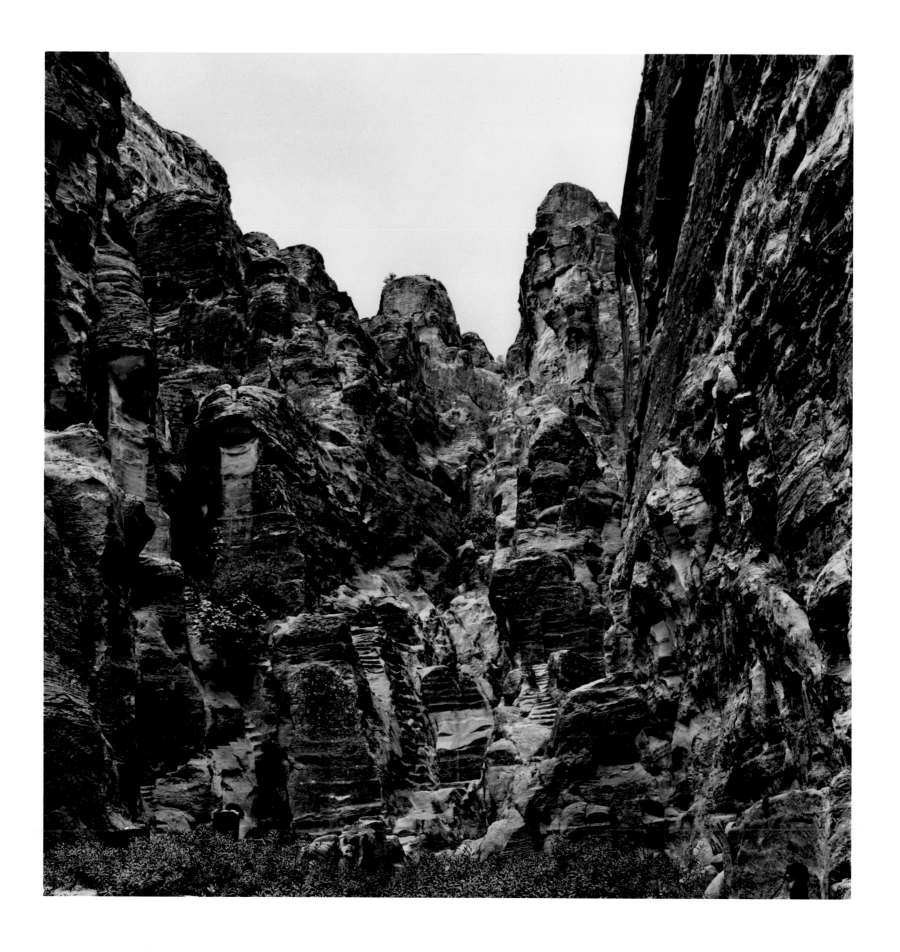

Older Passageway to Attuf High Place Near El Khazneh, Petra, Jordan, 1983

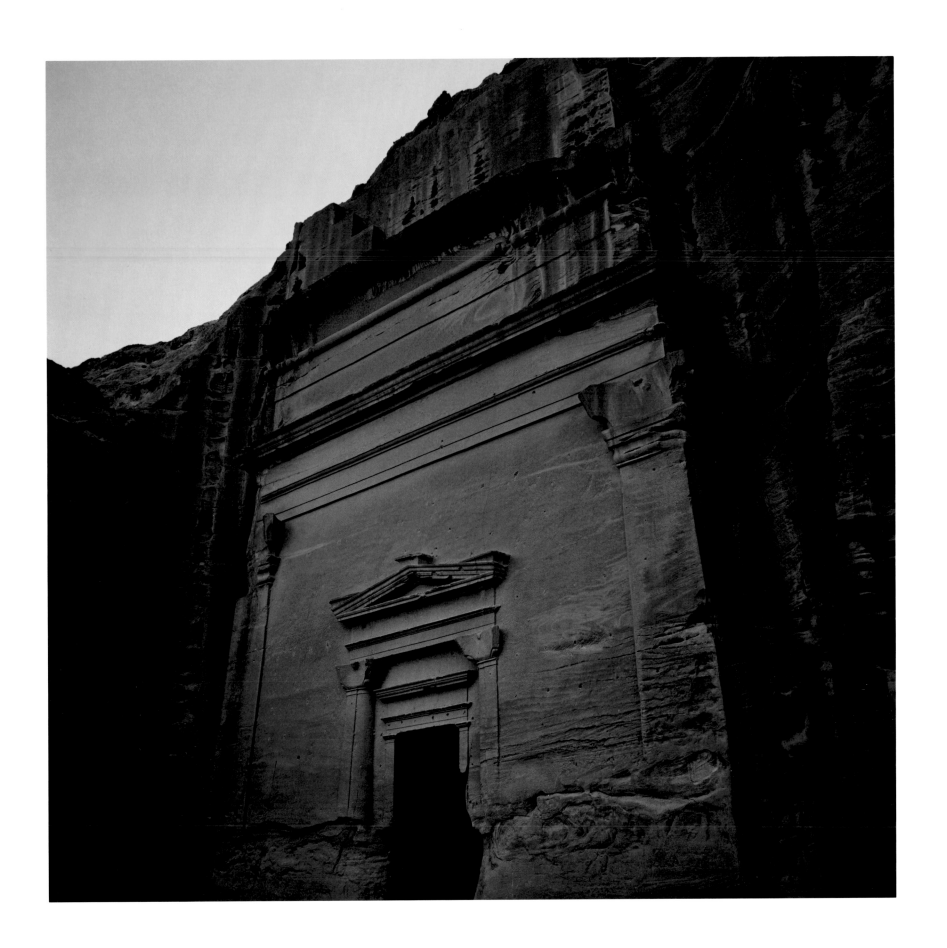

Tomb 813, Outer Siq, Petra, Jordan, 1985

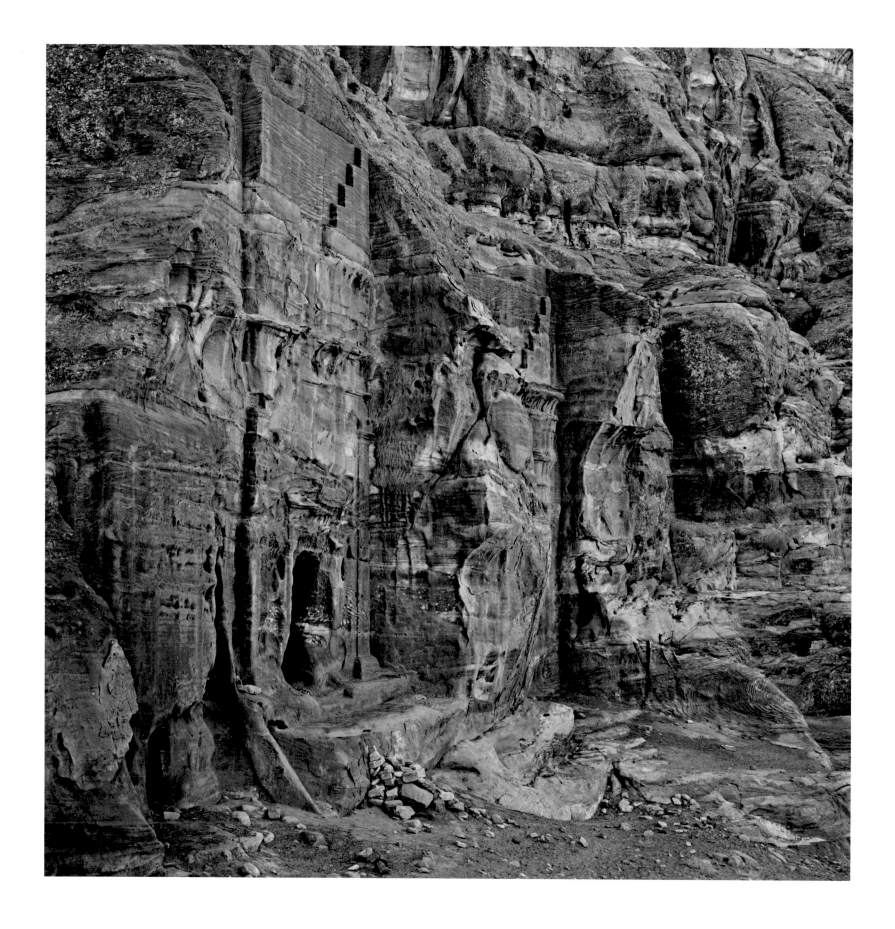

Petra, Jordan, 1985

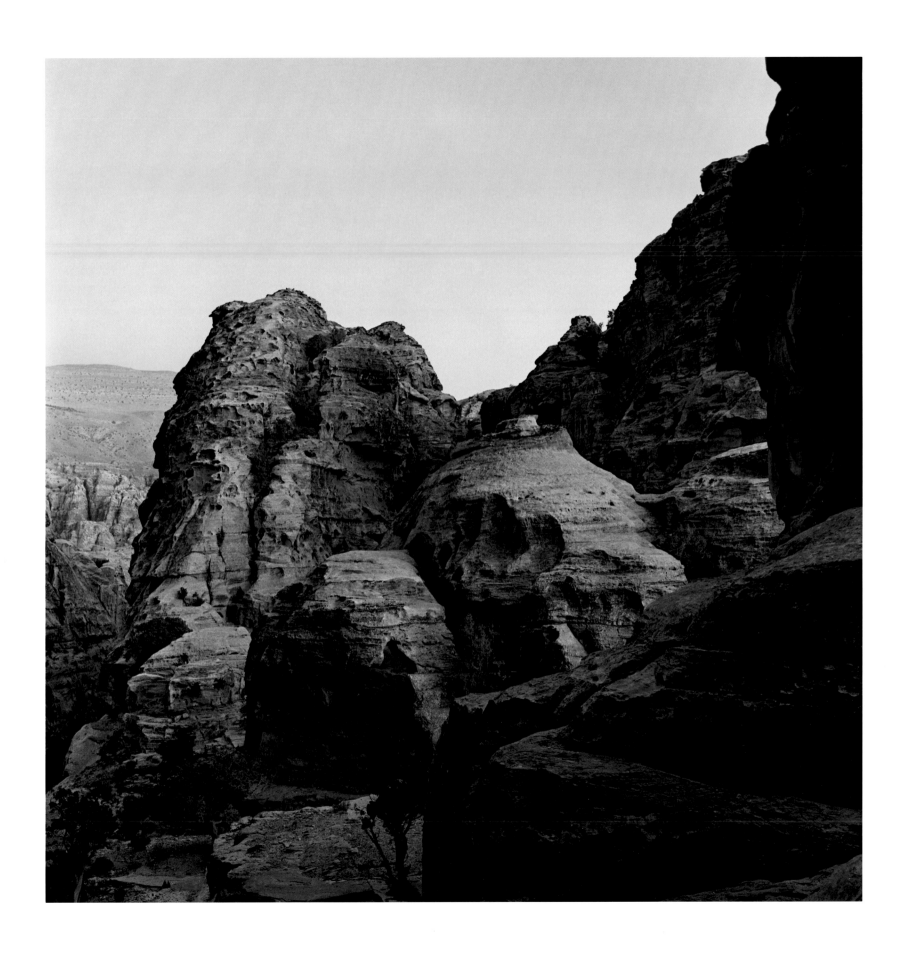

Jebel el Deir, Petra, Jordan, 1982

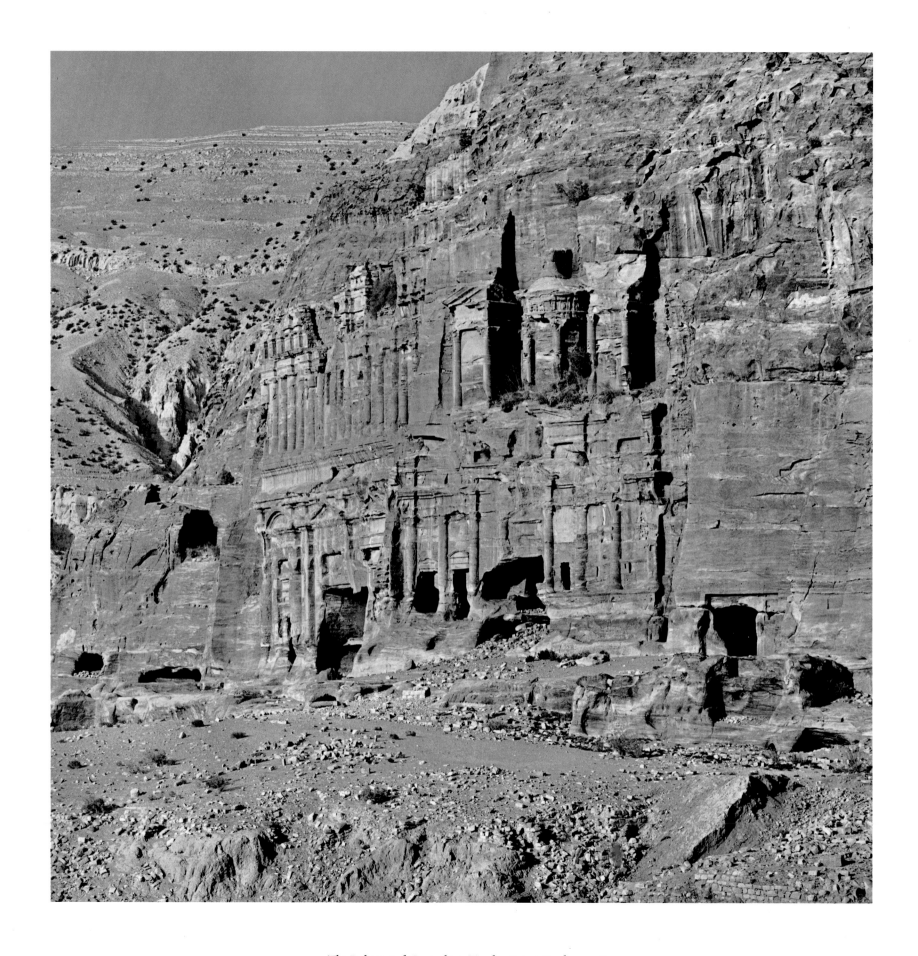

The Palace and Corinthian Tombs, Petra, Jordan, 1982

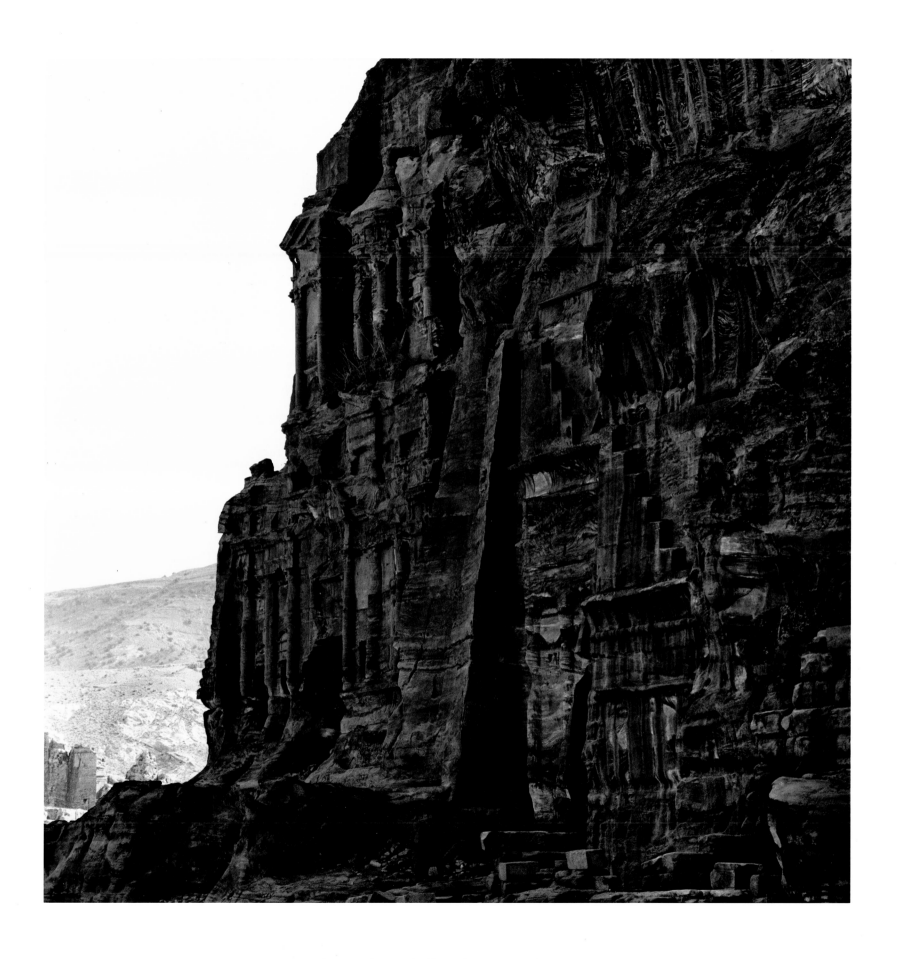

The Corinthian and Silk Tombs, Petra, Jordan, 1982

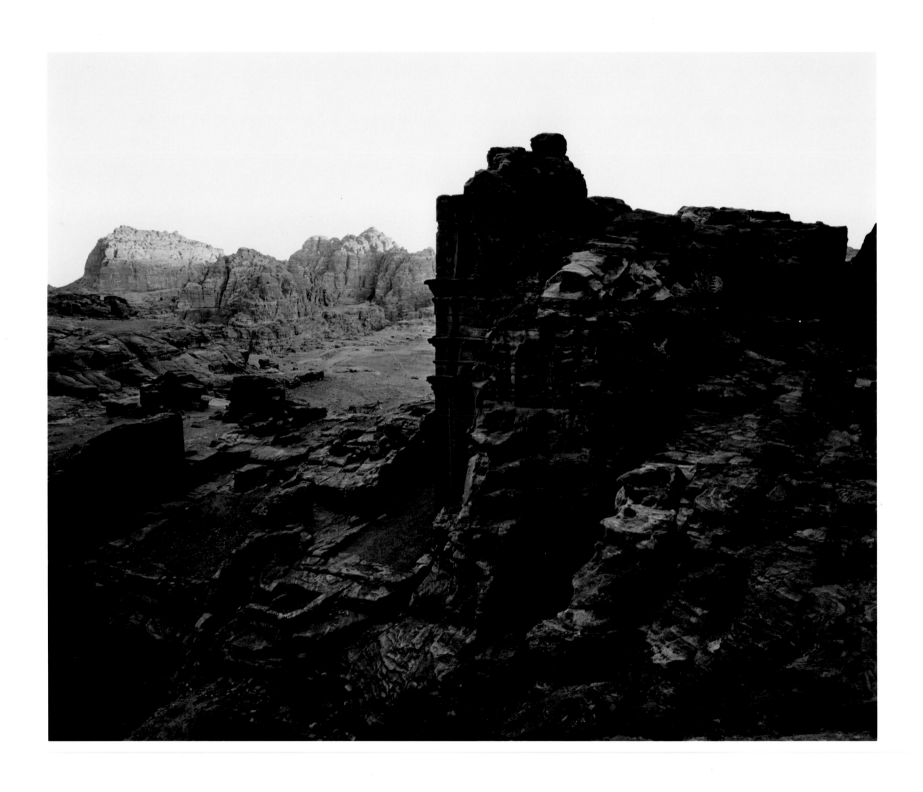

Tomb, Outer Siq, Petra, Jordan, 1985

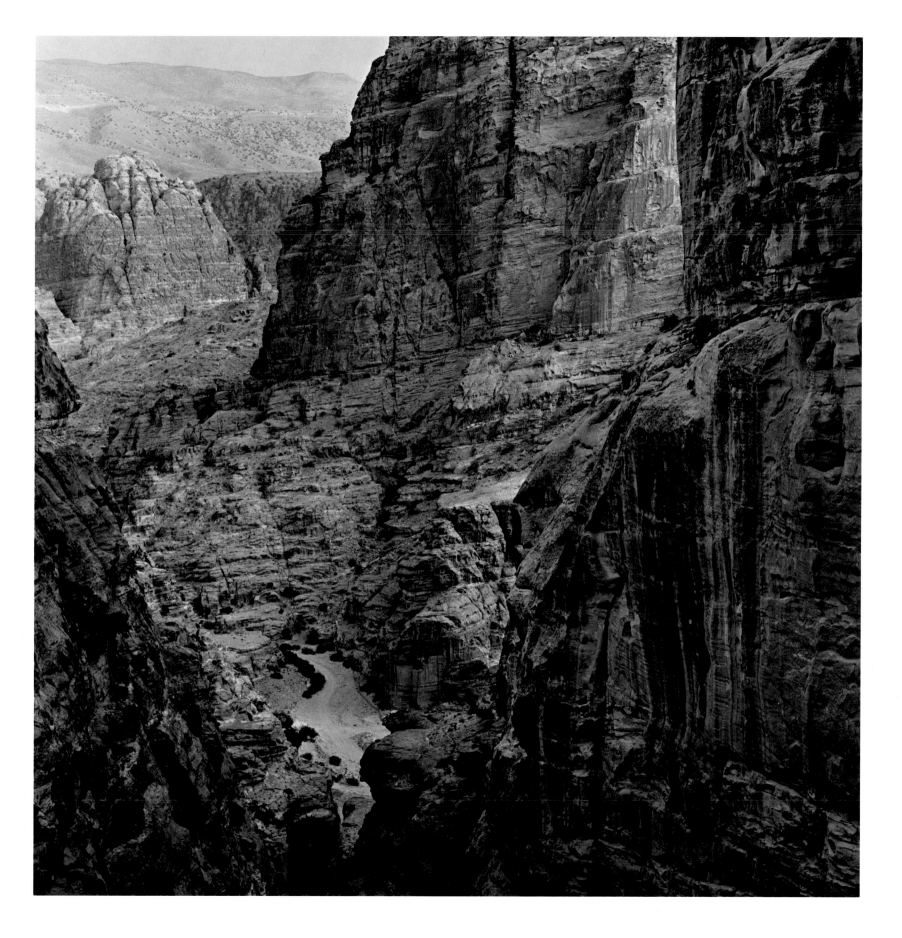

Wadi, Siyagh, Petra, Jordan, 1982

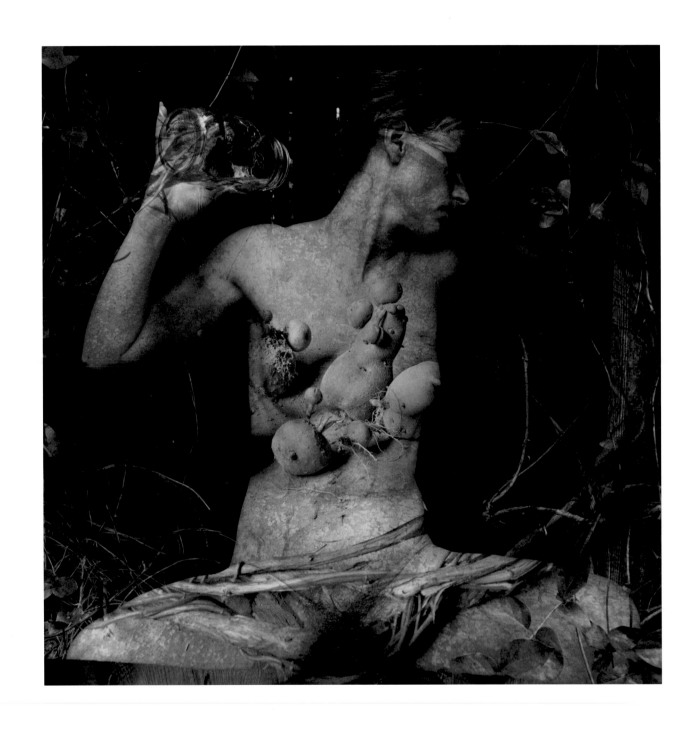

Edith, 1986

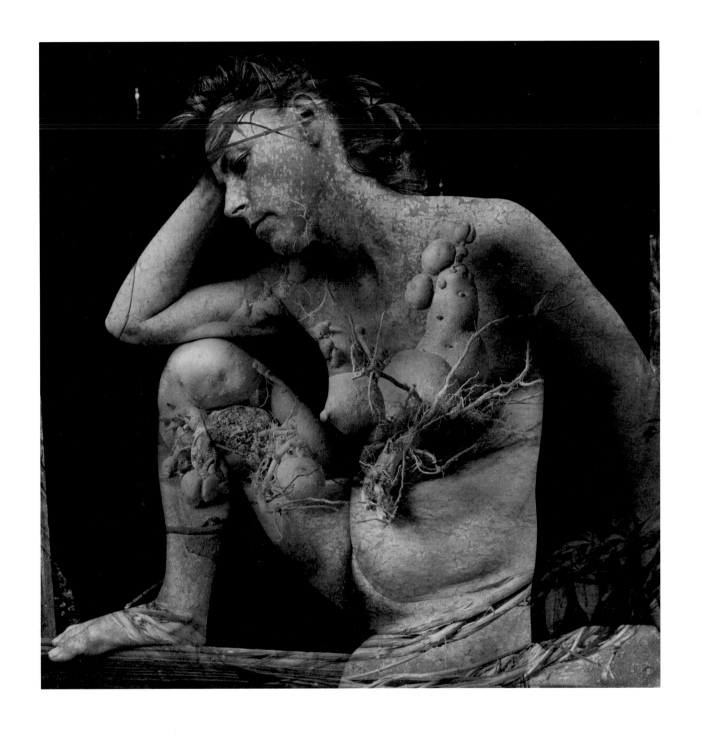

Edith, 1986

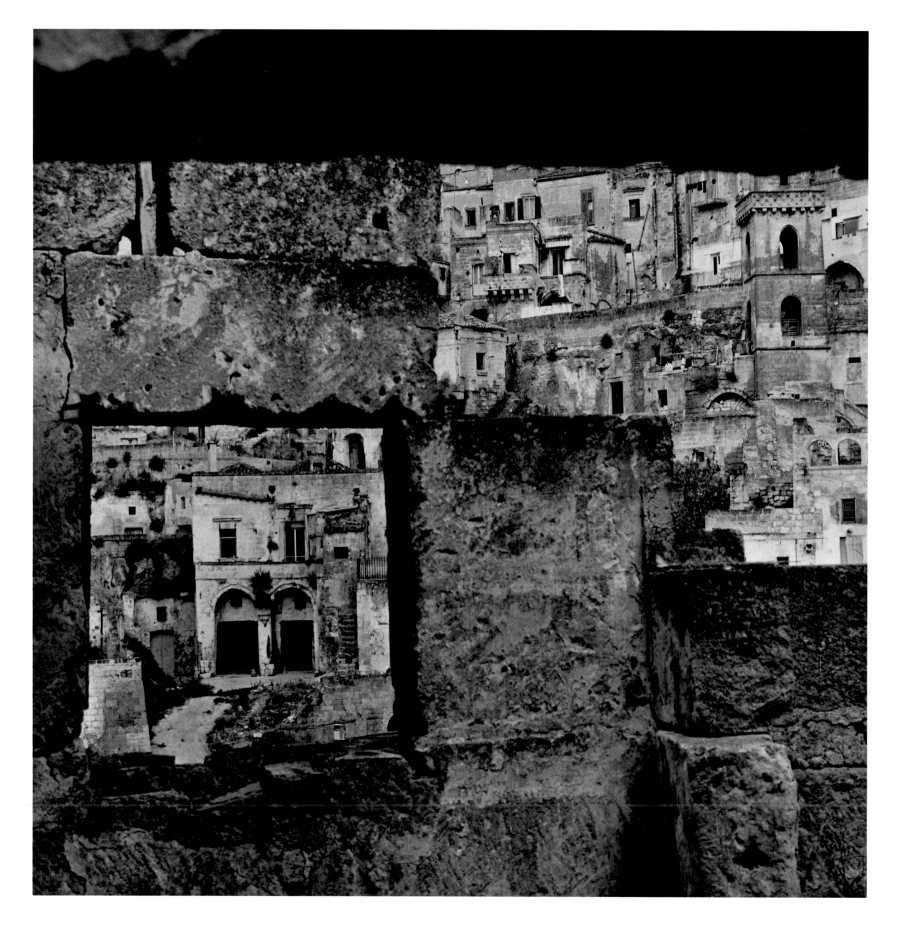

Matera, Italy, 1982

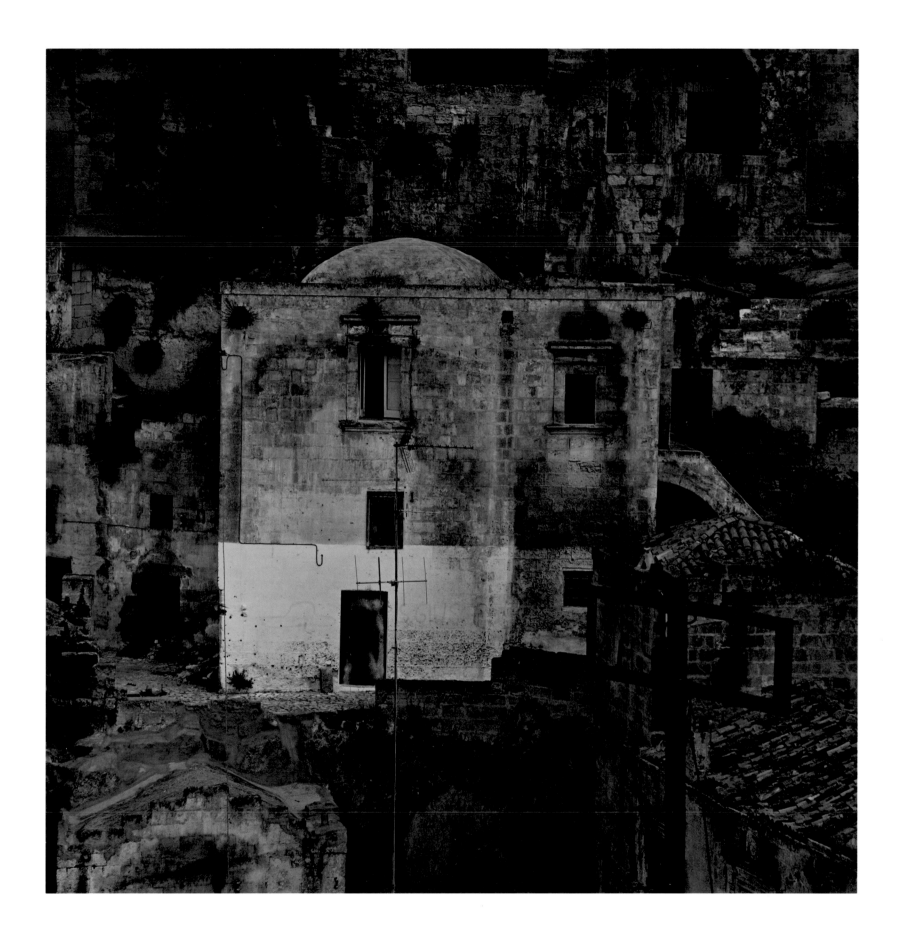

Matera, Italy, 1982

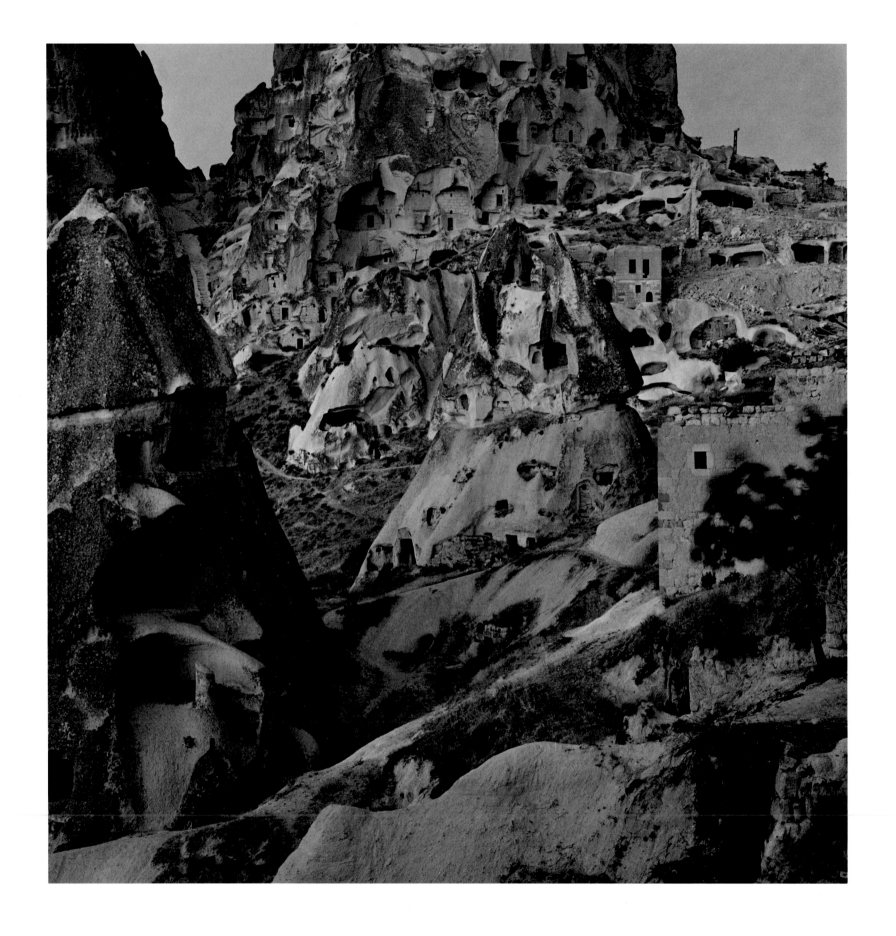

Uchisar, Turkey, 1985

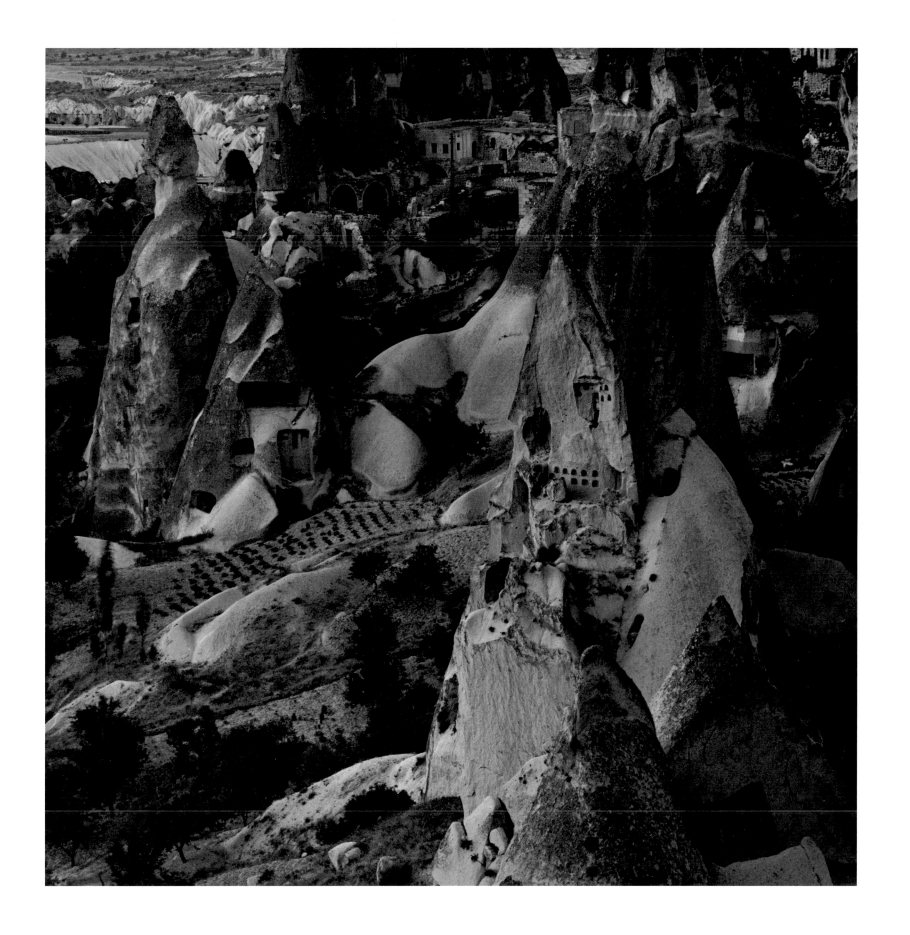

Uchisar, Turkey, 1985

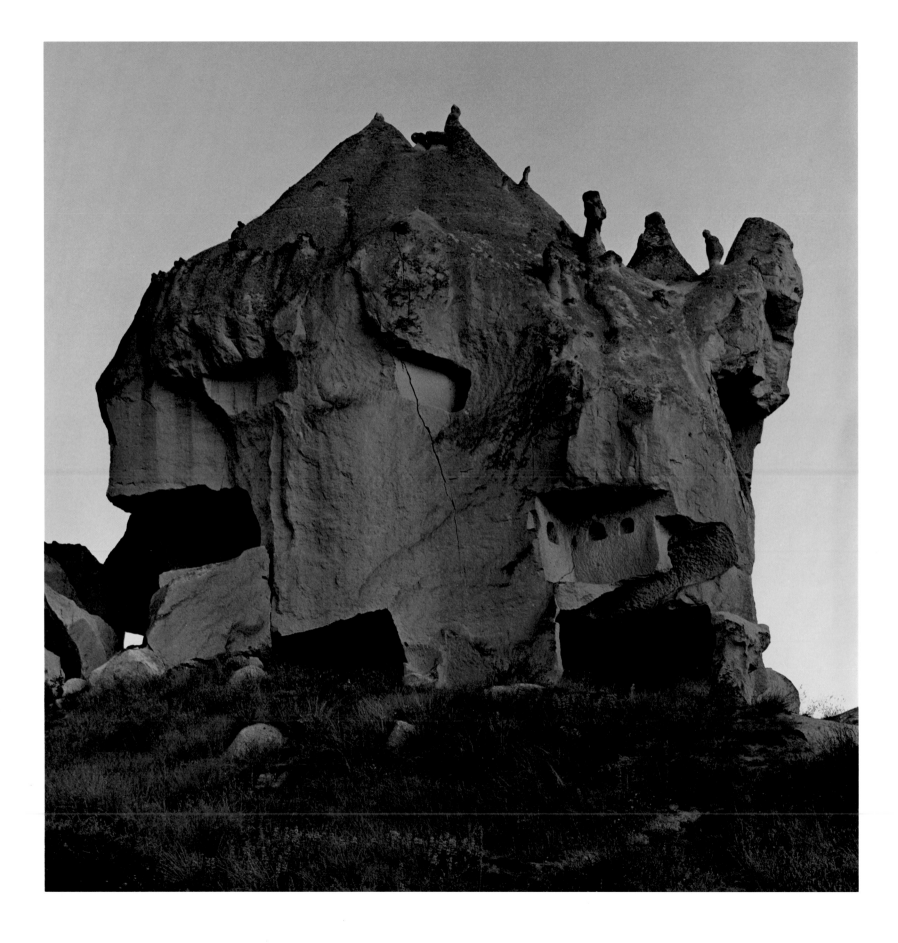

Zelve, Turkey, 1985

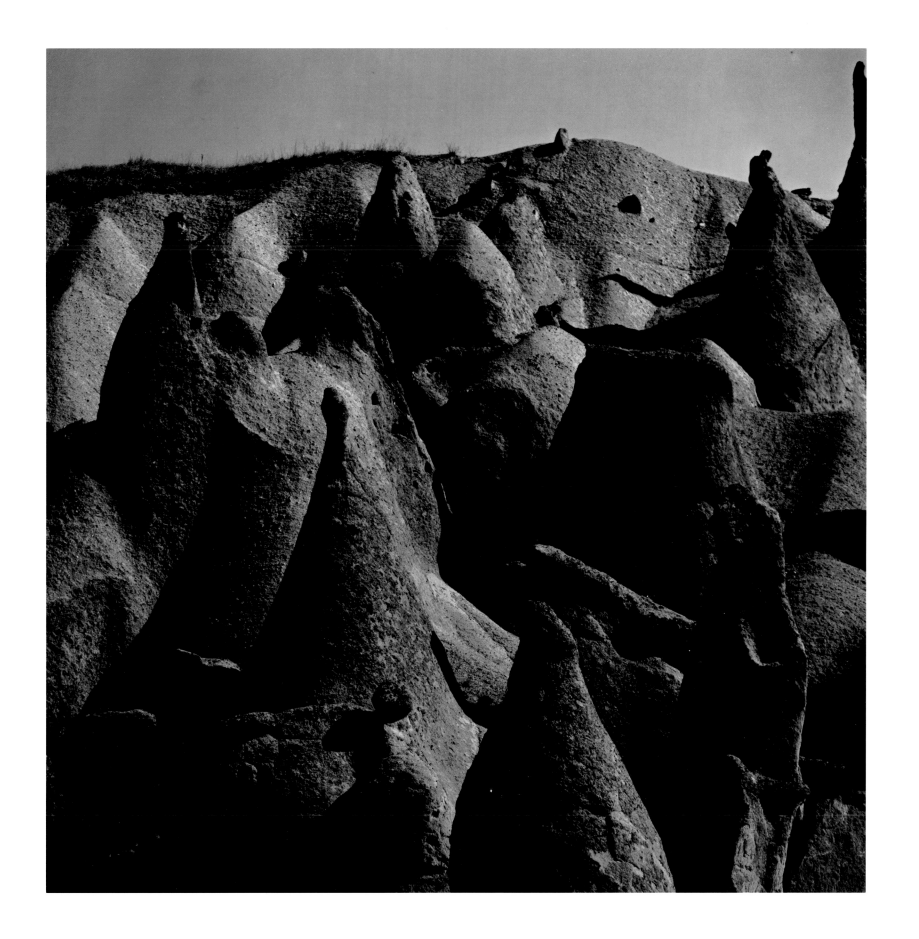

Zelve, Turkey, 1985

Though the gas smelled like mustard in dense concentrations, in low concentrations, still extremely toxic, it was hardly noticeable. It persisted for days and even weeks in the field. A gas mask alone was no longer sufficient protection. Mustard dissolved rubber and leather; it soaked through multiple layers of cloth. One man might bring enough back to a dugout on the sole of his boot to blind temporarily an entire nest of his mates. Its odor could also be disguised with other gases. The Germans sometimes chose to disguise mustard with xylyl bromide, a tear gas that smells like lilac, and so it came to pass in the wartime spring that men ran in terror from a breeze scented with blossoming lilac shrubs.

RICHARD RHODES

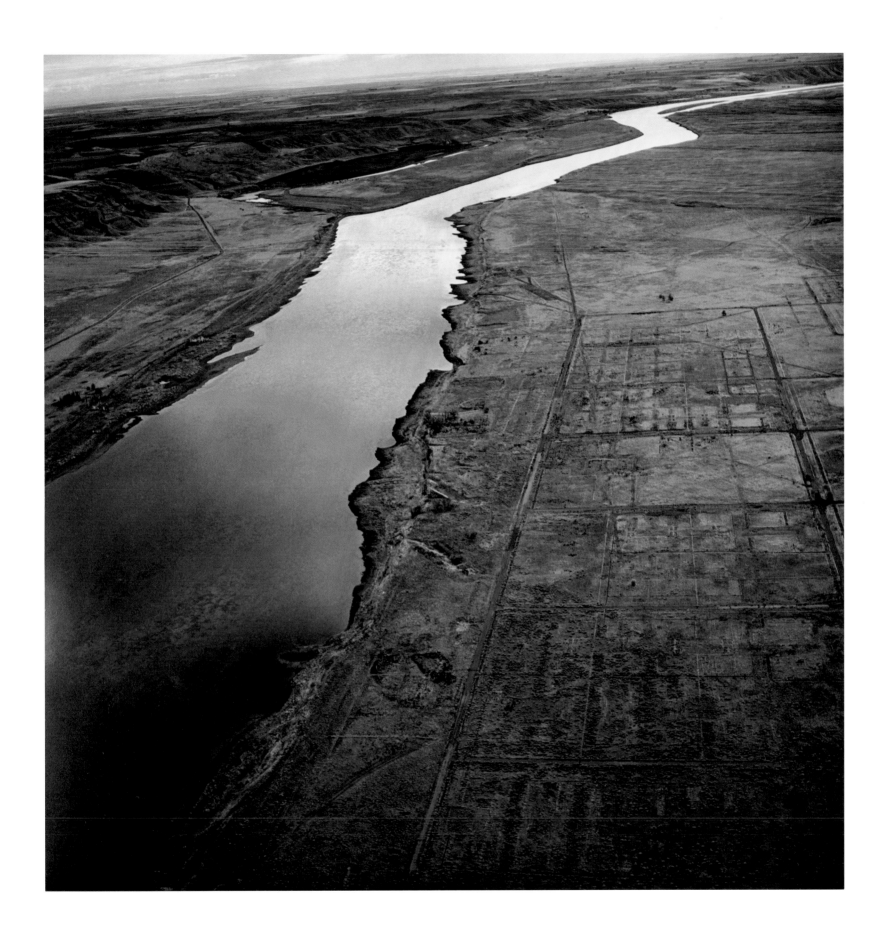

Old Hanford City Site and the Columbia River, Hanford Nuclear Reservation Near Richland, Washington, 1986

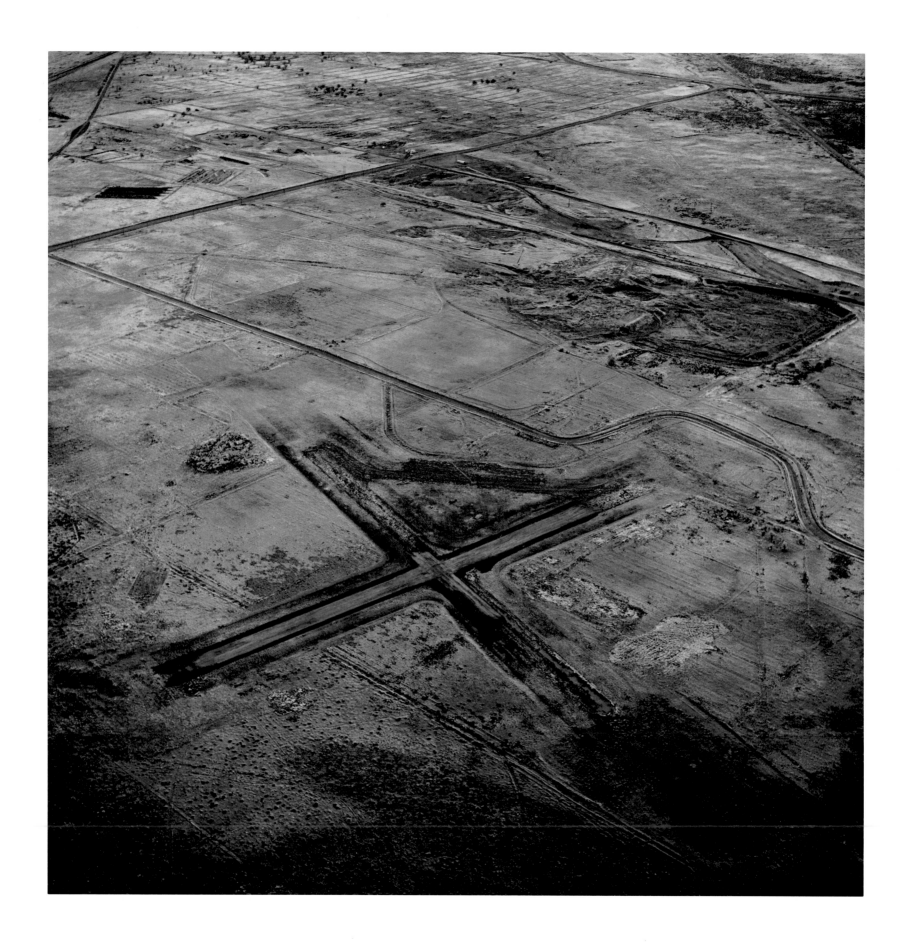

Abandoned Air Field and Old Hanford City Site, Hanford Nuclear Reservation Near Richland, Washington, 1986

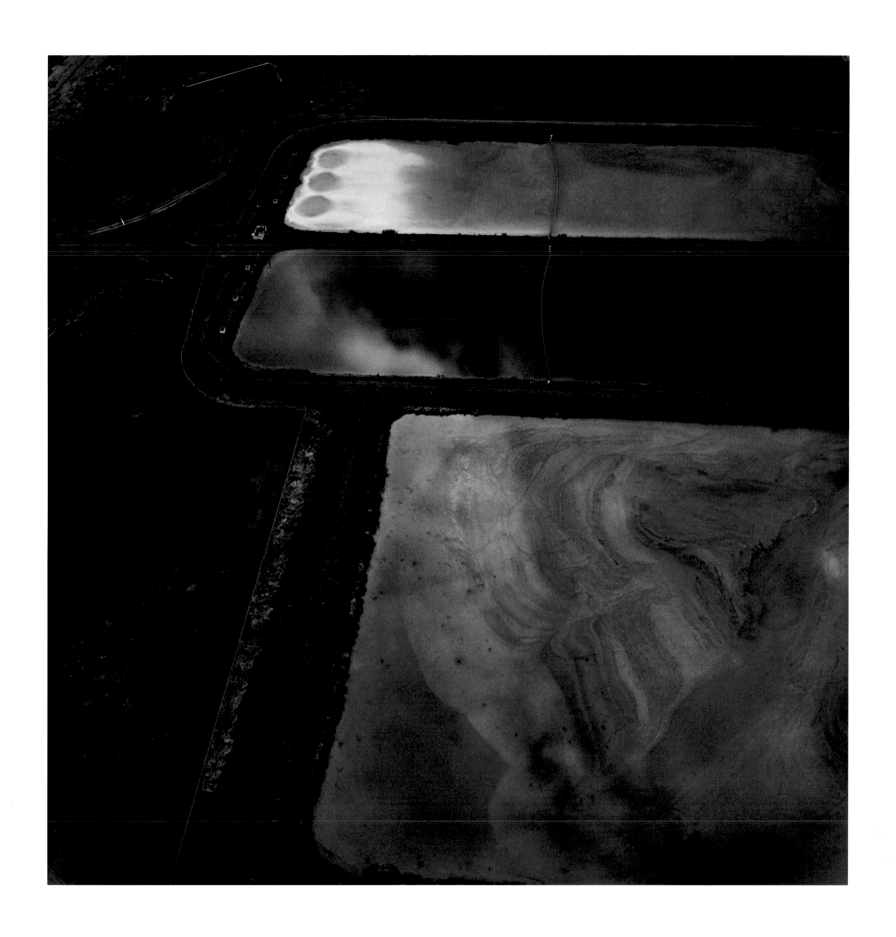

Water Treatment Pond at the Confluence of the Willamette and Columbia Rivers, Portland, Oregon, 1986

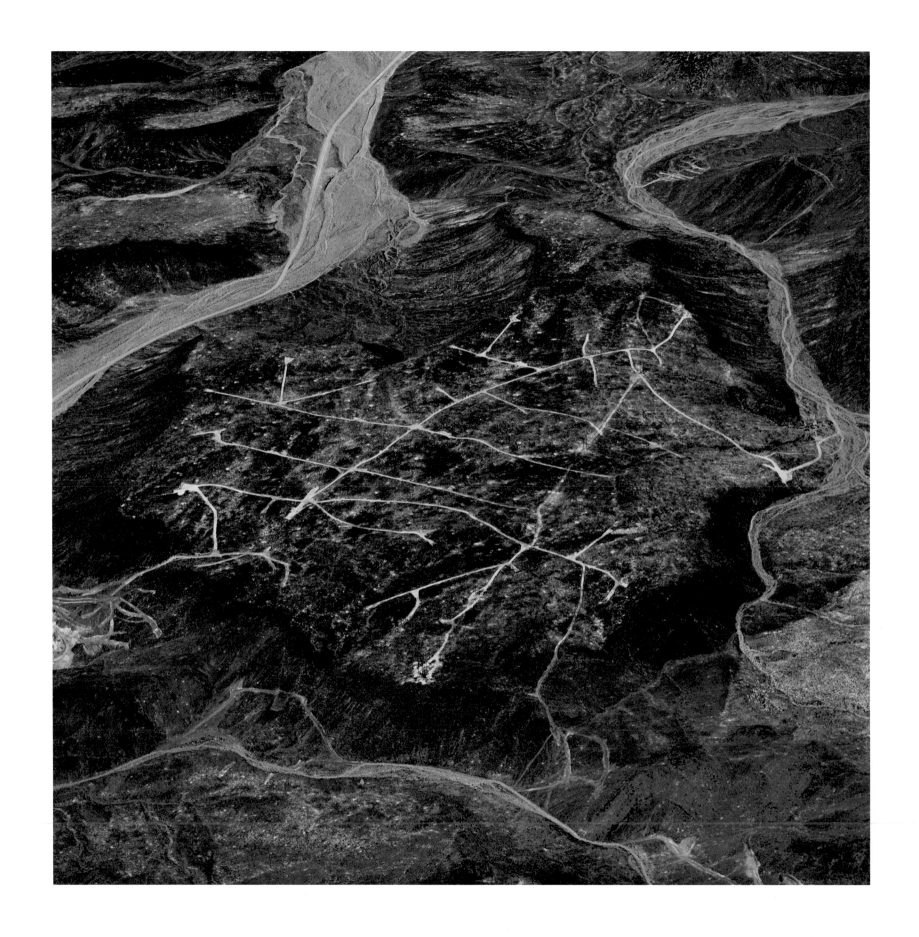

Mining Exploration, Utah, 1988

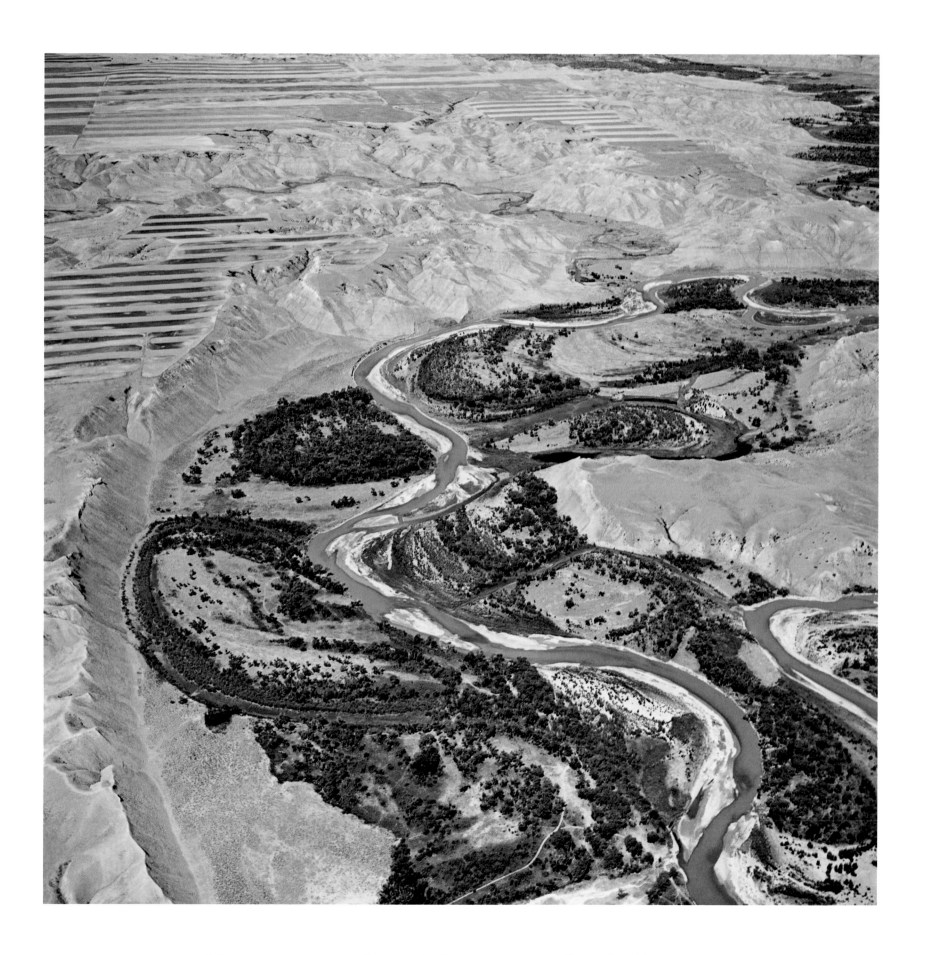

Braided Stream, Marias River, and Dry Land Wheat Farming, Great Falls Missile Field, Montana, 1987

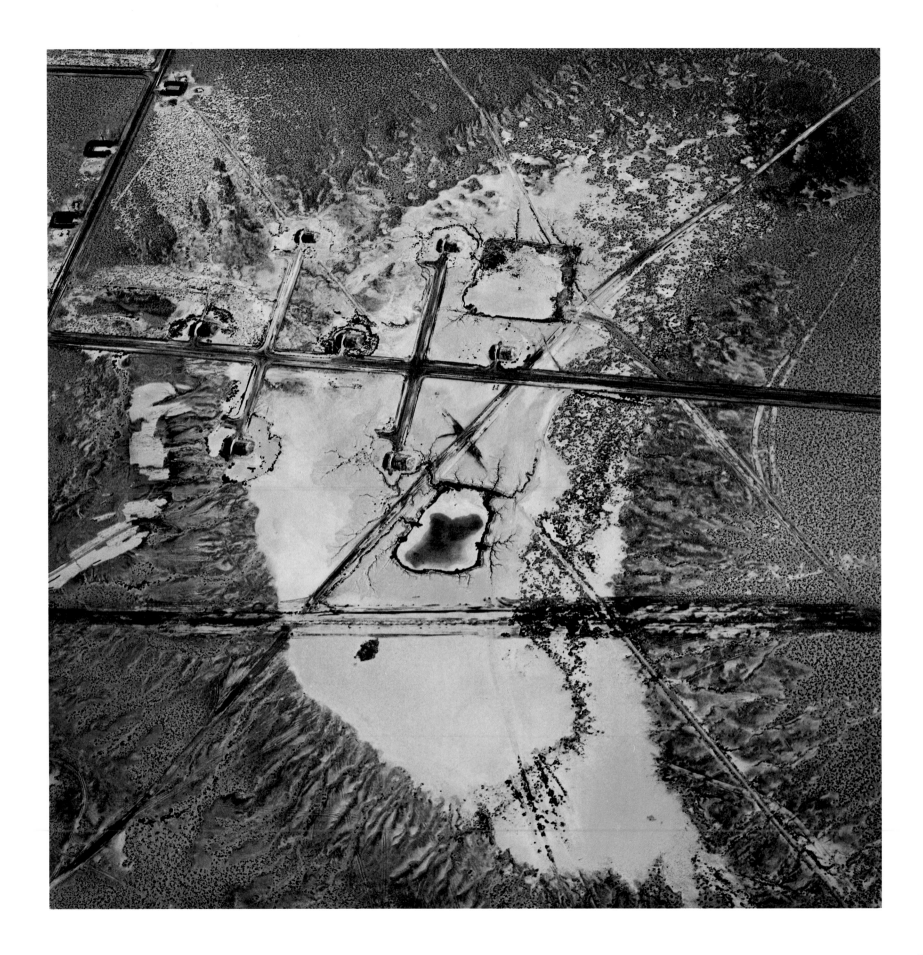

Ammunition Storage, Hawthorne, Nevada, 1988

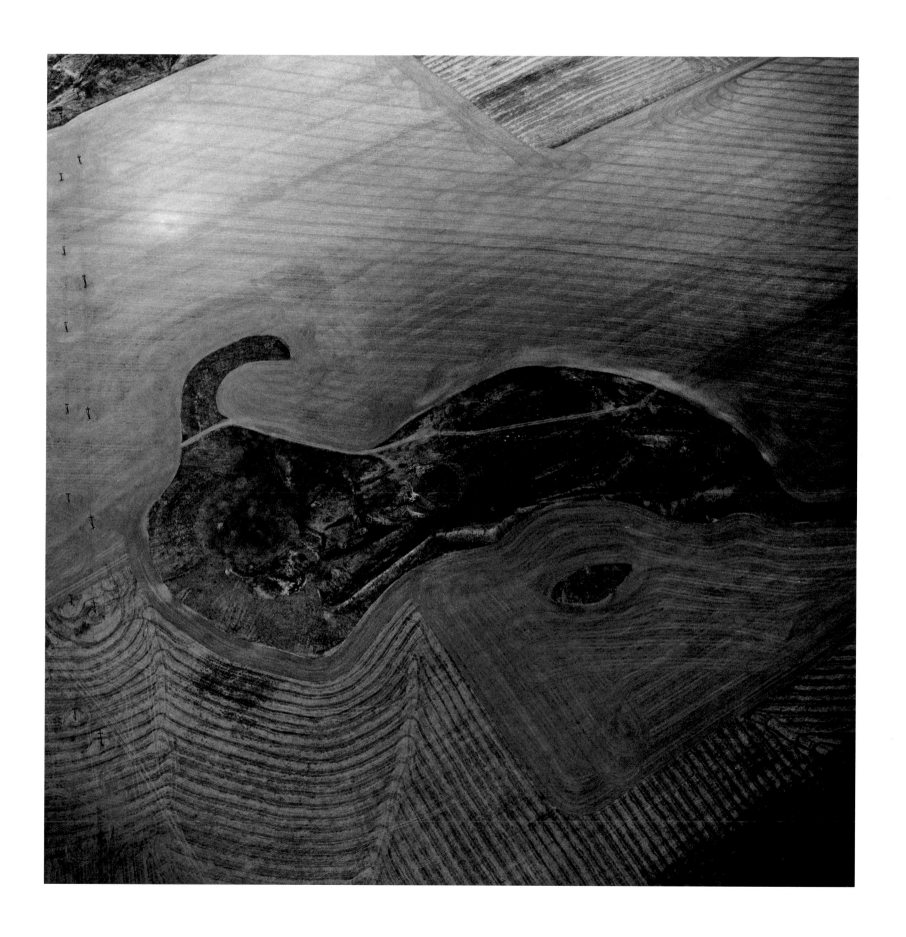

Glacial Kettle, Wheat Field, and Glory, Great Falls Missile Field, Montana, 1987

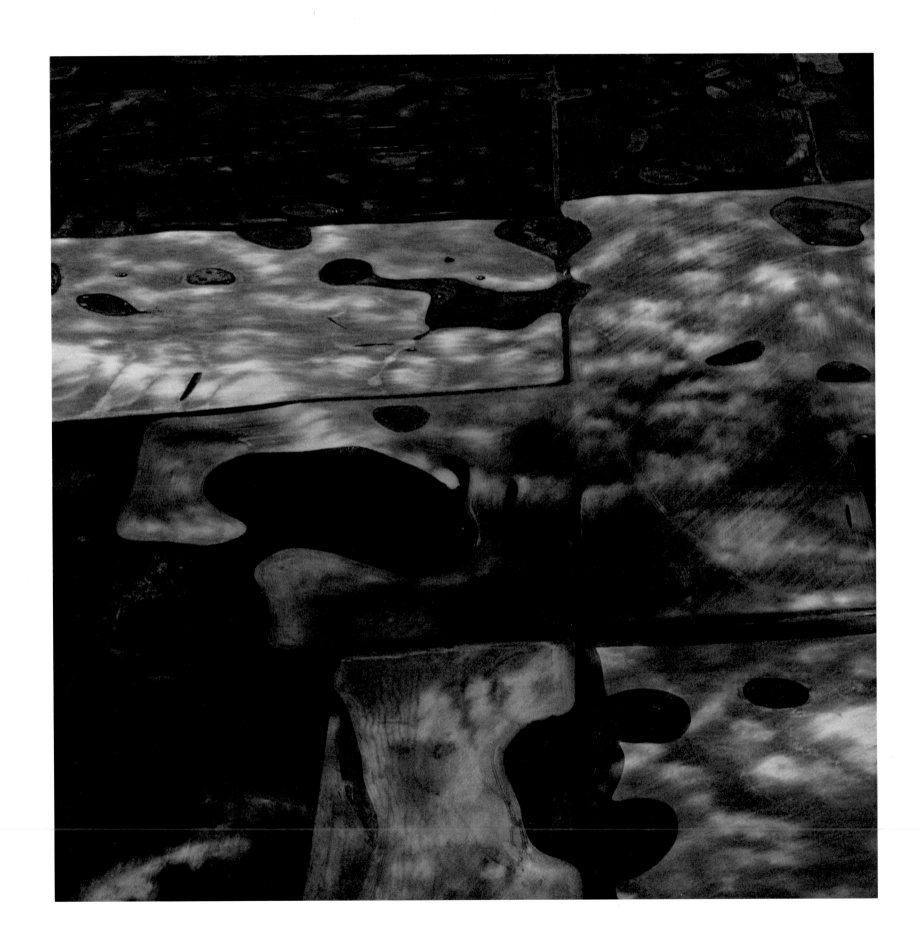

Wheat Fields and Glacial Kettle, North Dakota, 1987

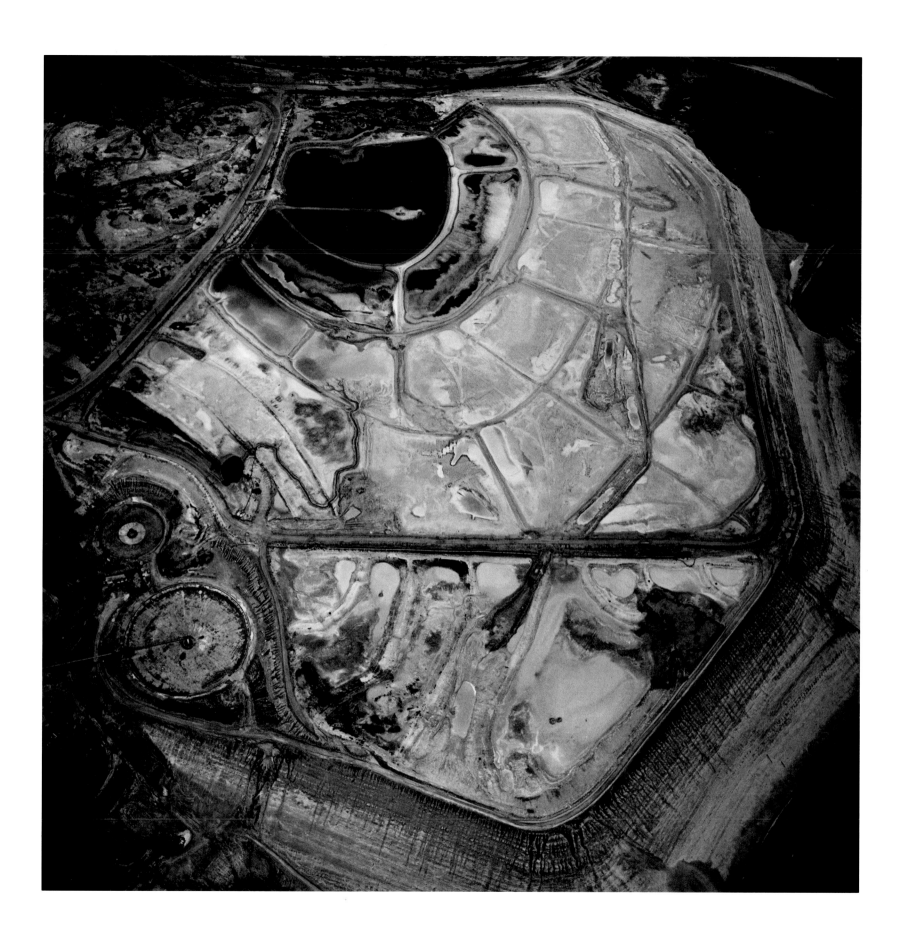

Copper Ore Tailing, Globe, Arizona, 1988

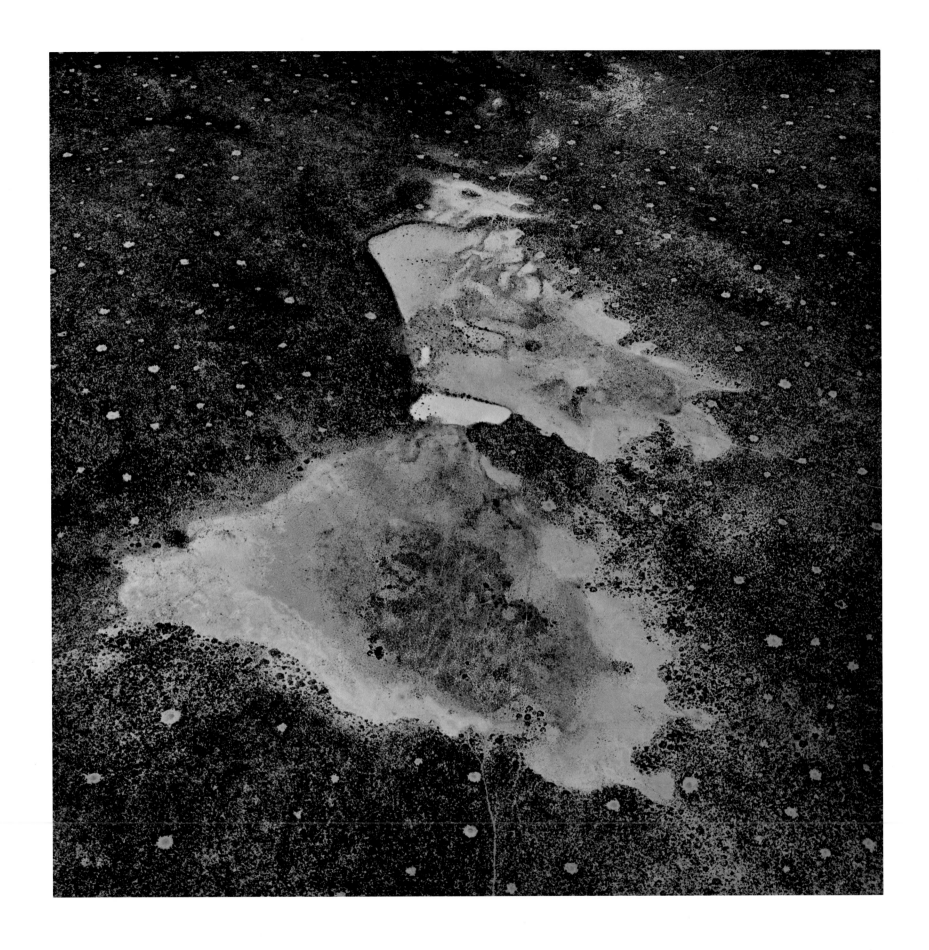

Dry Watering Hole and Wash Near the Very Large Array, Magdalena, New Mexico, 1988

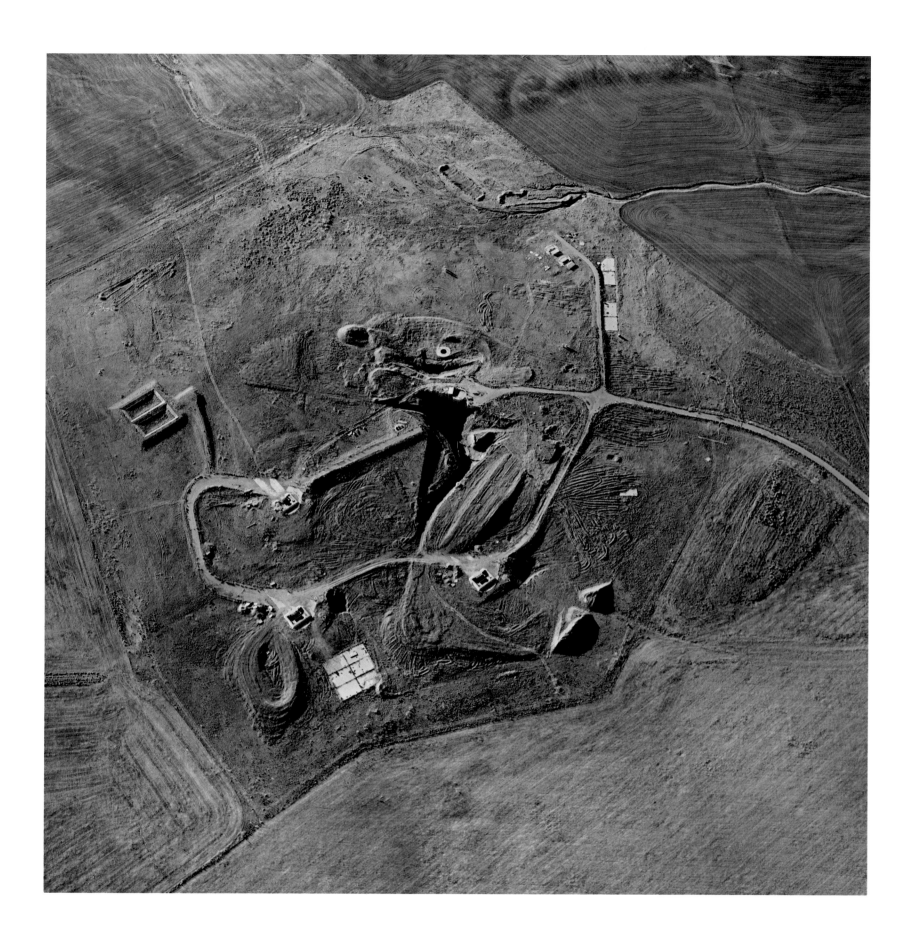

Abandoned Titan Missile Silo, Mountain Home, Idaho, 1987

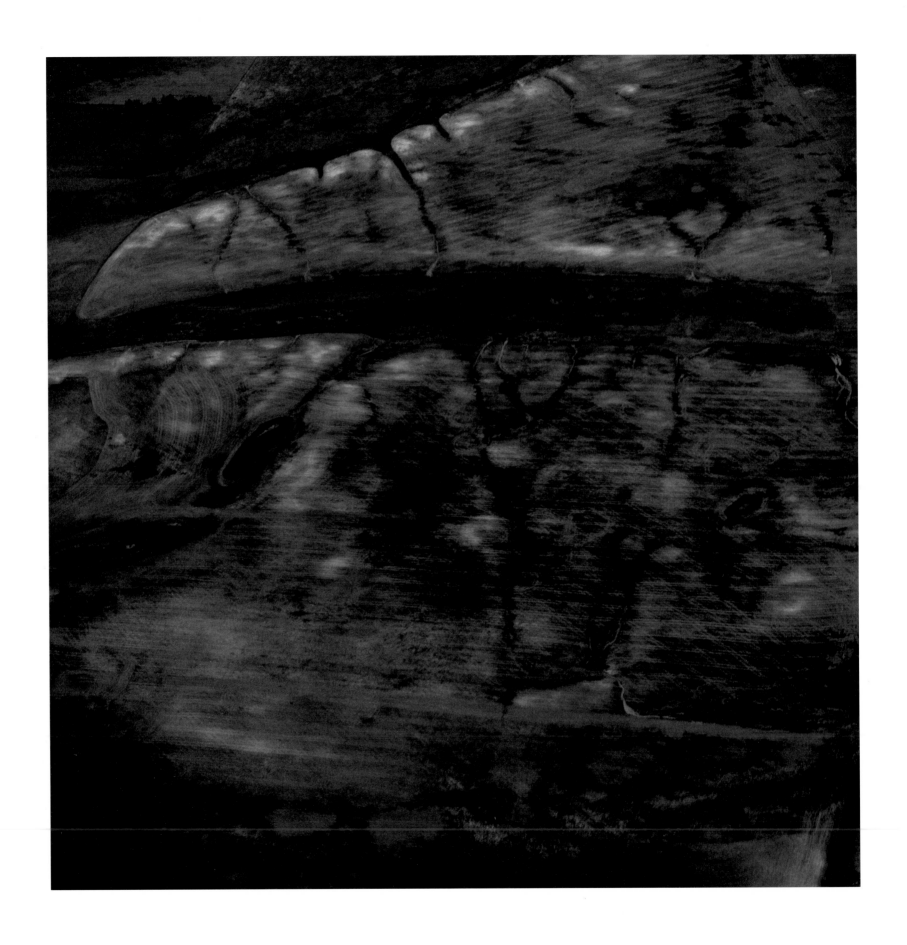

Glacial Wheat Fields, North Dakota, 1987

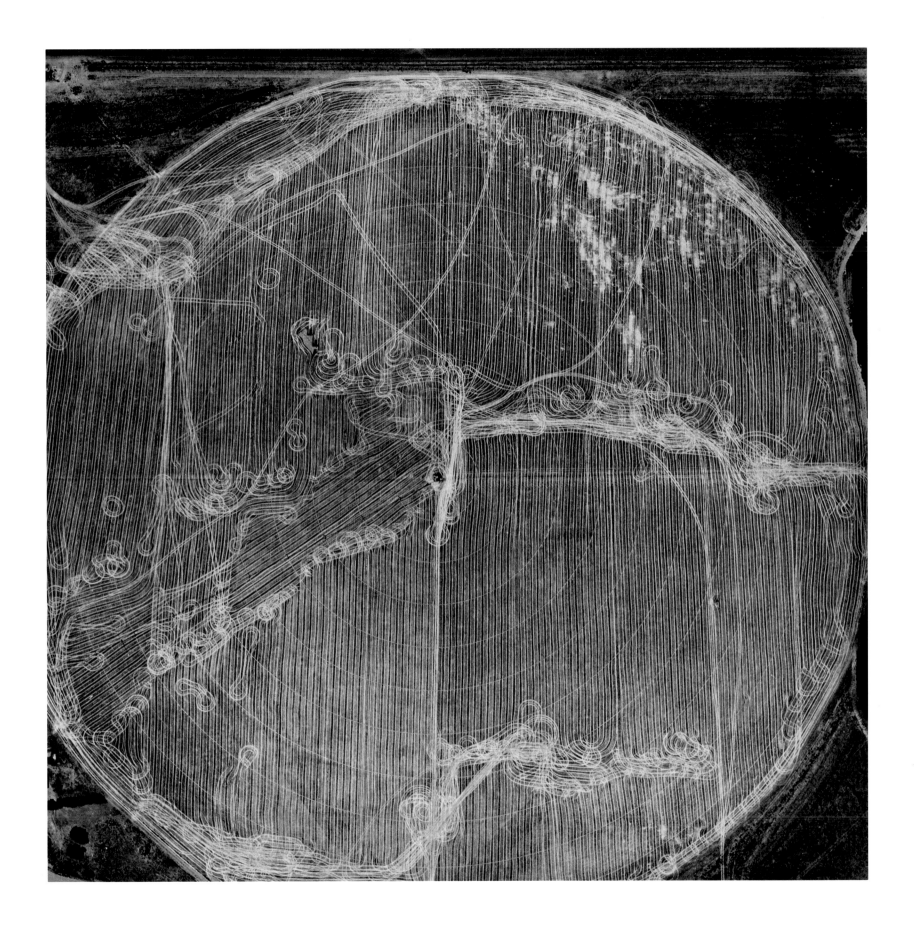

Pivot Agriculture, Washington, 1987

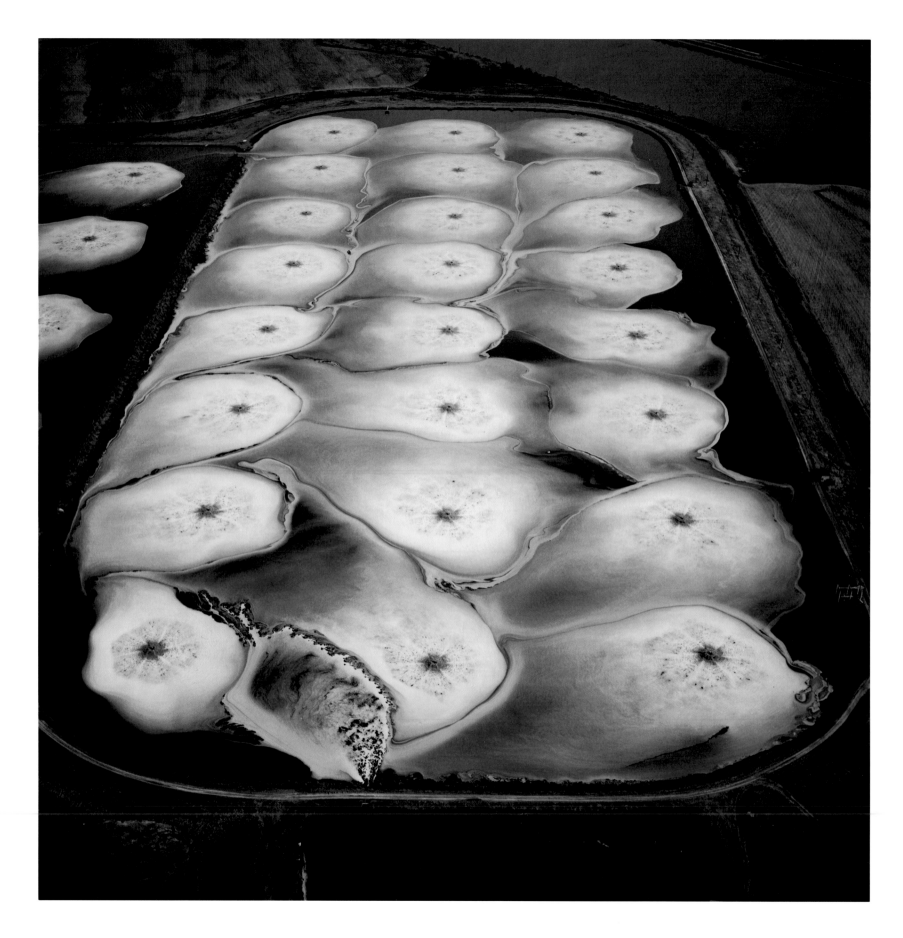

Aeration Pond, Toxic Water Treatment Facility, Pine Bluff, Arkansas, 1989

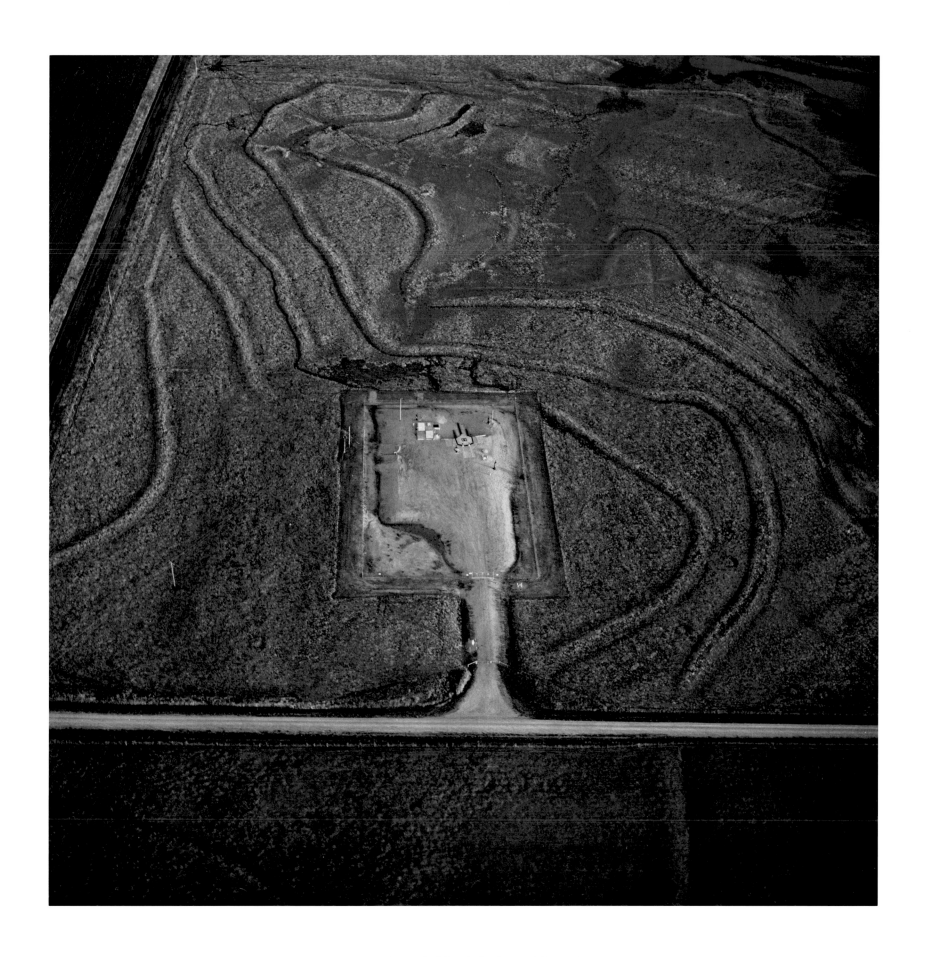

Minuteman II Missile Silo, Knob Noster, Missouri, 1988

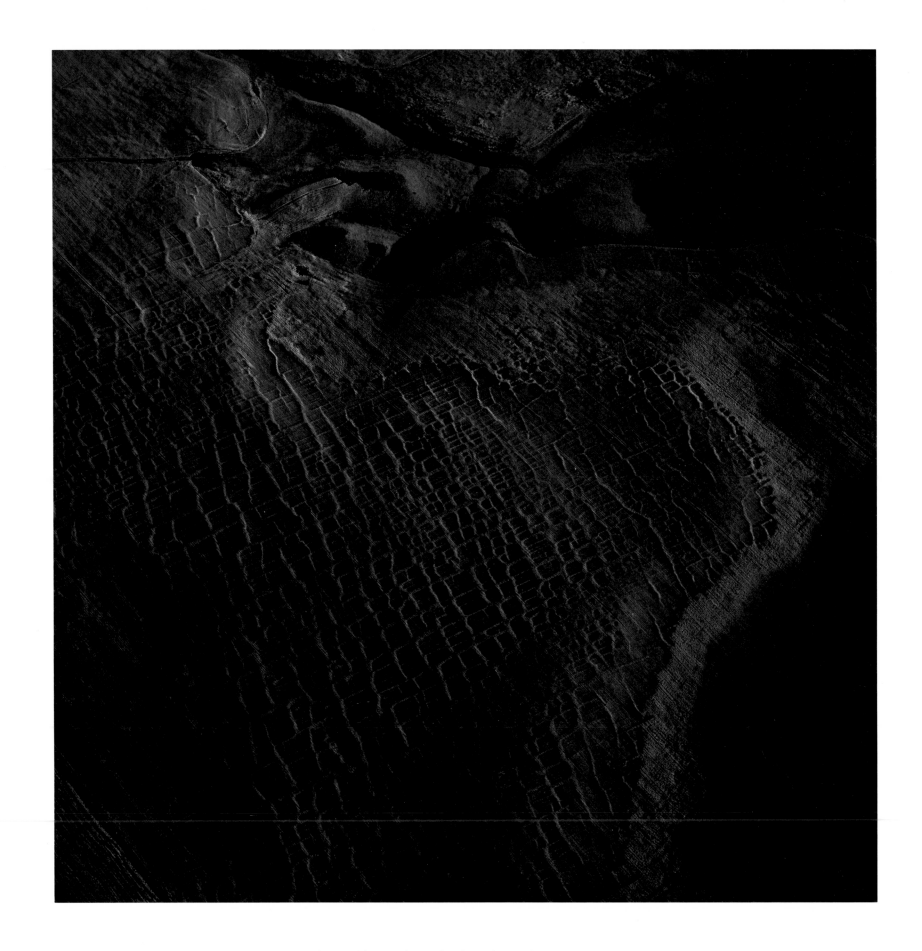

Wheat Field Near the Auchard Creek Missile, Montana, 1988

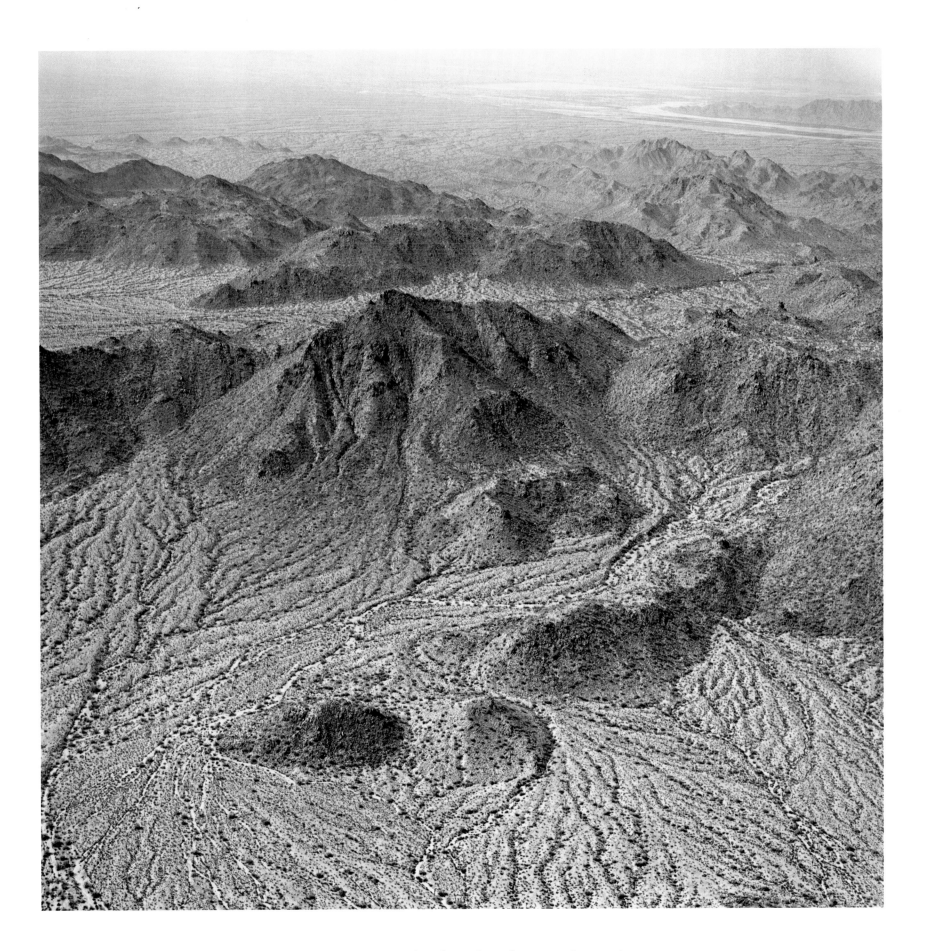

Natural Drainage Systems Near the Palo Verde Nuclear Power Station, Arizona, 1988

Designed by Eleanor Caponigro
Set in Monotype Dante by Michael and Winifred Bixler
Halftone photography made from the original photographs
by Robert J. Hennessey
Printed on Warren LOE Dull by Franklin Graphics
and bound by Roswell Book Binding